Faces of Jazz

A Tribute

Paintings & Prose

by

Rudy Browne

For Ariana, Aaron and especially Judith Ann whose presence makes me whole.
And my two guys, Connor and Jasper.

Copyright © 2013 Rudy Browne
All rights reserved

ISBN-10-1491026685
ISBN-13:978-1491026687

Jazz quotes from *allaboutjazz.com*
Photo of the author by Judy Browne
Cover painting: *Ron Carter 2*

Foreword

I grew up in a musical household in the San Francisco Bay Area. My father believed there was music to satisfy every taste, from classical to country, even jazz. My passion for jazz was ignited after hearing Lionel Hampton's "Midnight Sun." The resonant and mellow sound of the vibes became my milestone to jazz. A chance meeting with Chet Baker on a Sausalito rooftop and seeing Dave Brubeck perform at my high school sealed my fate. The Bay Area was mesmerizing with its sights and sounds. It was electric and alive with jazz, from the Burma Lounge in Oakland to the coffee houses in North Beach. The landmark clubs: The Blackhawk, Jazz Workshop, El Matador and Jimbo's Bop City headlined the biggest names in jazz. It was magical!

My formative years in the Bay Area were smack in the middle of the *Golden Decade of Jazz*, (mid 50's to 60's). Nothing was more exciting than experiencing live jazz. Every set featured different versions of known pieces, original compositions full of suspense and surprises, the solos going in all directions. All the money I earned went to jazz records and jazz gigs.

Jazz is the purest American art form. It is subjective and complex. As with all art, what one gleans from it is in direct proportion to what one brings to it. If one listens and unravels a minute particle of jazz's complexity, rewards abound and revisits filled with delightful surprises.

In 2004, I began painting portraits of favorite musicians, giving faces to unseen artists. The project became *Faces of* Jazz; a tribute to jazz musicians. To date, I have completed nearly sixty portraits. The project is ongoing.

<div style="text-align: right;">The Author</div>

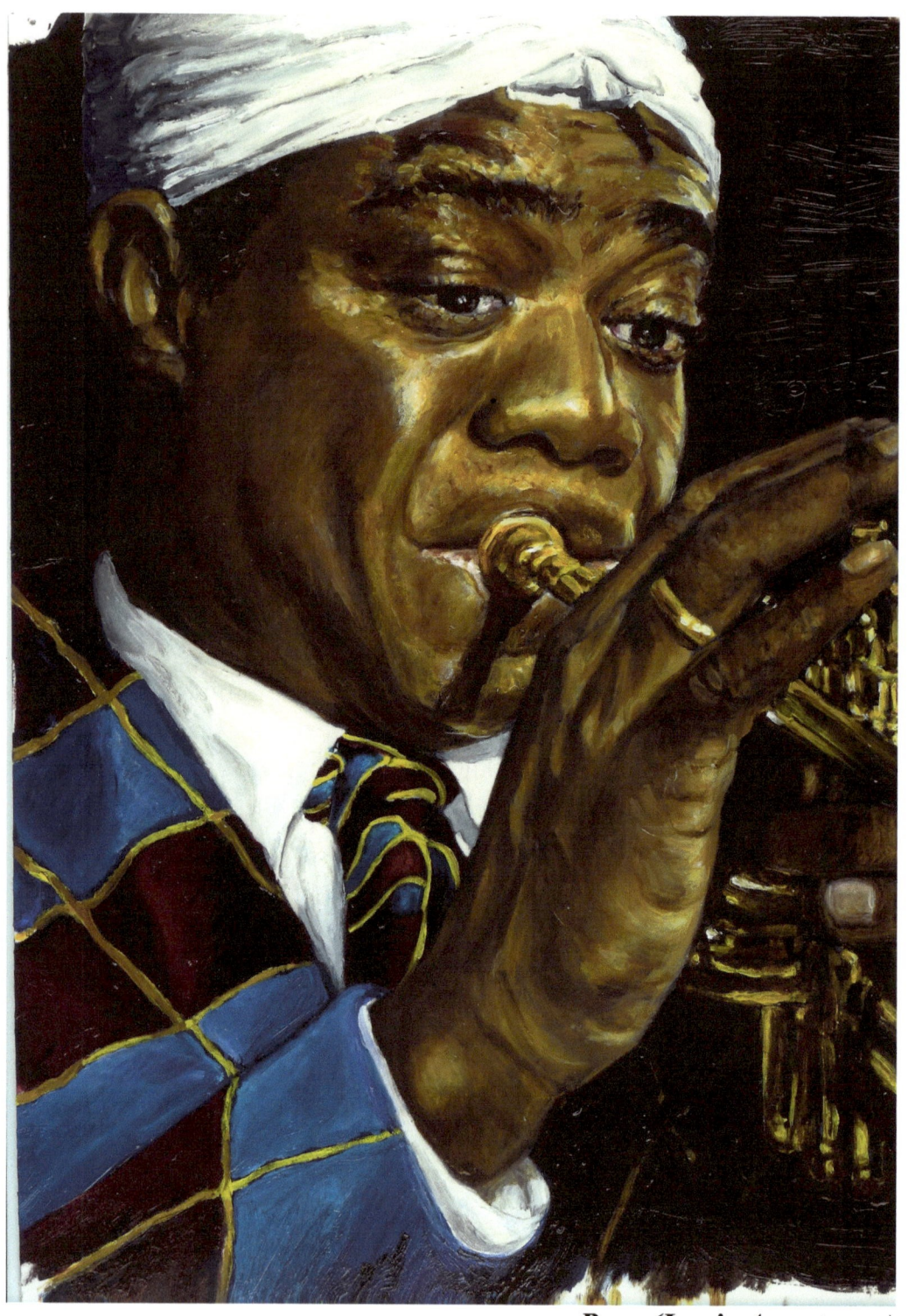

Pops (Louis Armstrong)

We all do "do, re, me," but you have got to find the other notes yourself. Man, if you have to ask what it is, you'll never know.
 --Louis Armstrong

Jazz Is

Jazz is the epitome of musical creativity

Jazz is reliving unforgettable memories

Recalling forgotten ones

Jazz is spontaneous

Cerebral

Free-form

Discordant

Jazz is aggressive

Loud

Frantic

Lyrical

Gentle

Jazz is an old friend

A love a touch away

An essential element in a world taking it for granted

And would be lacking by its absence.

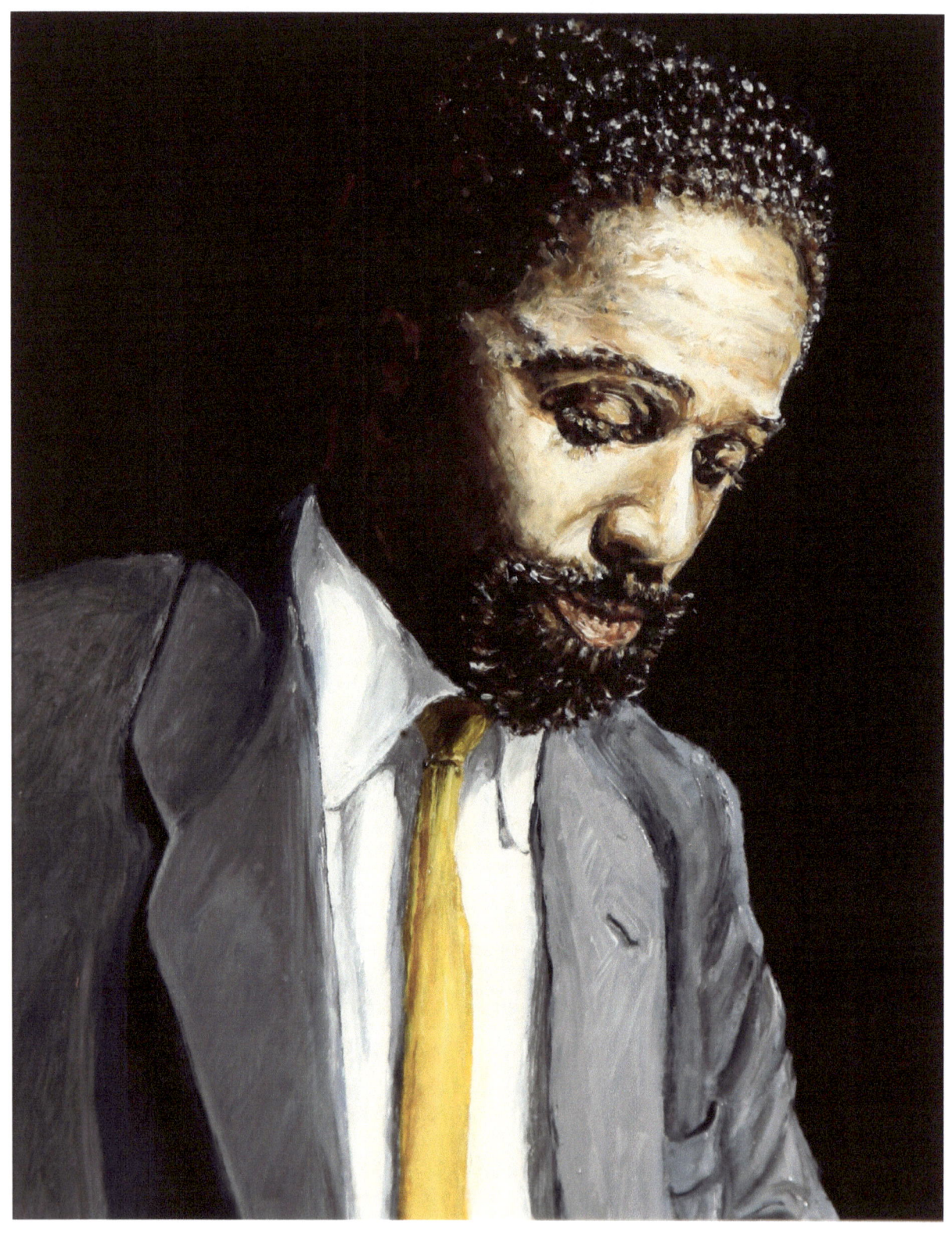

John Lewis

The reward for playing jazz is playing jazz.
　　　　　　　--John Lewis

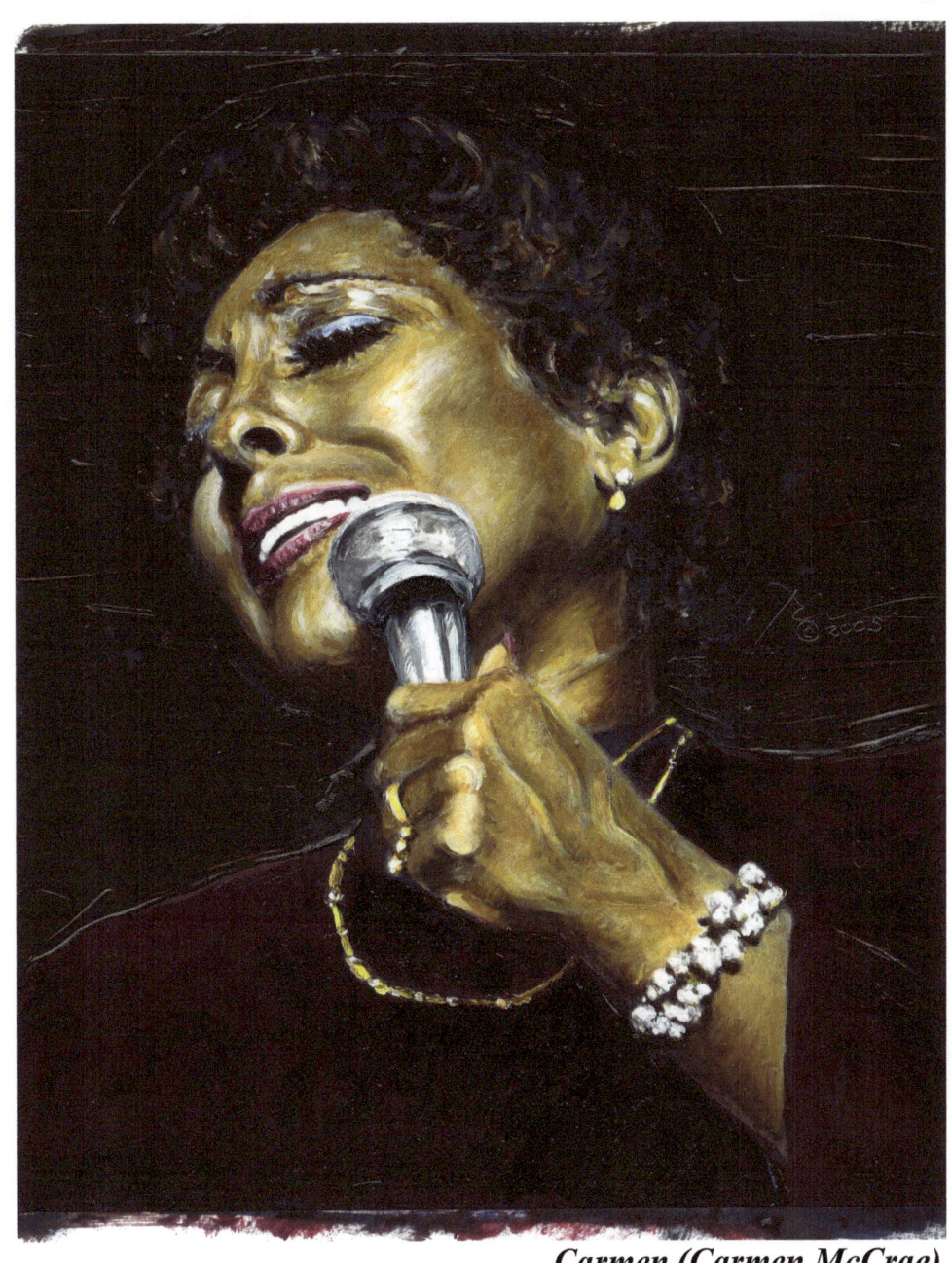

Carmen (Carmen McCrae)

Carmen

Seeing her in person
Singing just for you
Precise phrasing and pauses
Eloquent diction
Dimpled smile, closed eyes
Slowly opening, looking directly at you
My Future Just Passed.

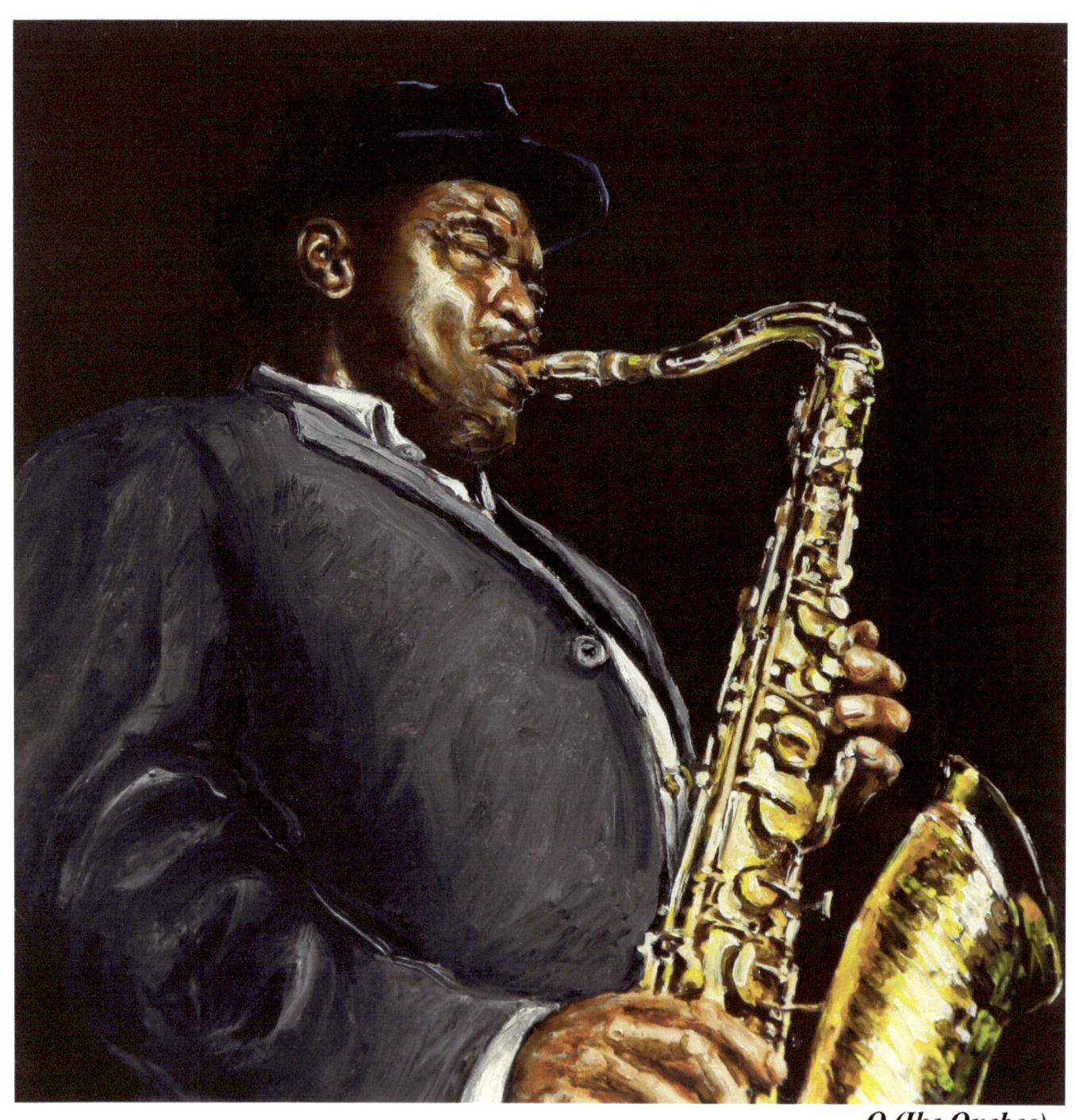

Q (Ike Quebec)

You are the music while the music lasts.
 --T.S. Eliot

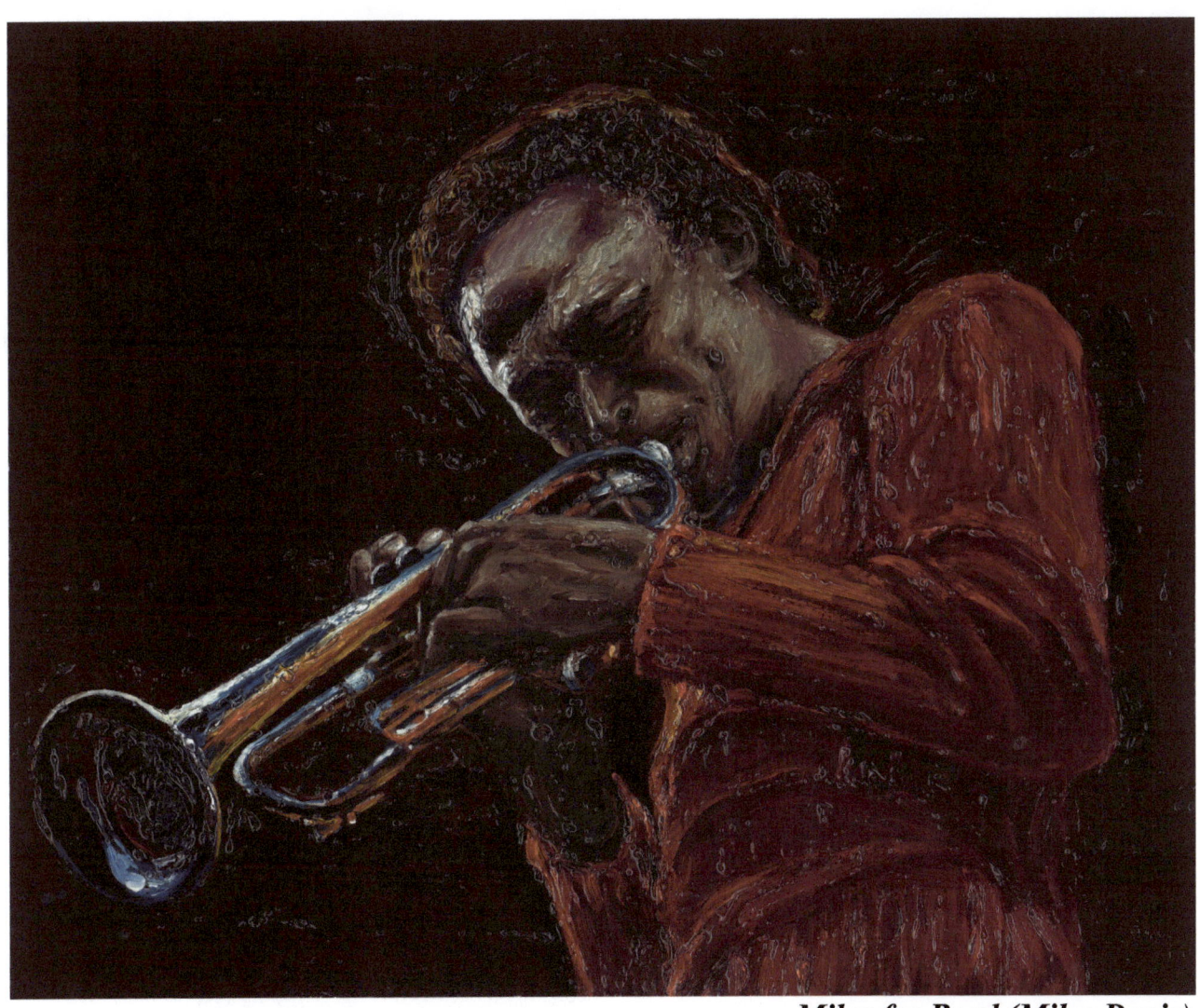

Miles for Brad (Miles Davis)

Miles

Muted, soulful, restrained
Achingly plaintive, unique
Mesmerizing middle register
Not realizing the held breath
Until exhaled
Weil revisited
Rodrigo enchanted
Concierto, bravo!

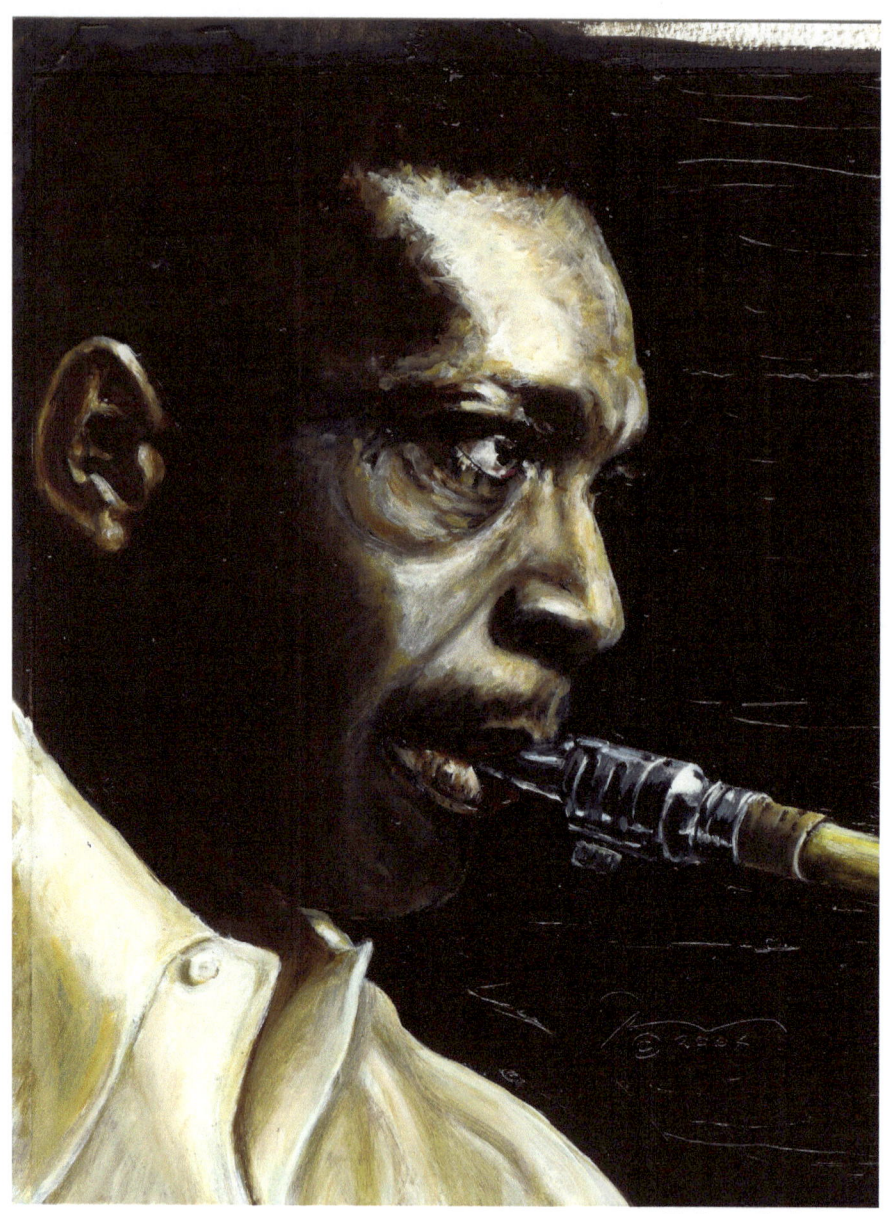

John Coltrane

Trane

"How come your solos are so long?"
"I have a lot to say"
Cascading notes
Giant bridges
Exhausting passages
Squawks, squeals

Subtle vision
Exquisite lyricism
The *Ballads* album
A must for every collection
Catching the Trane is exhilarating.

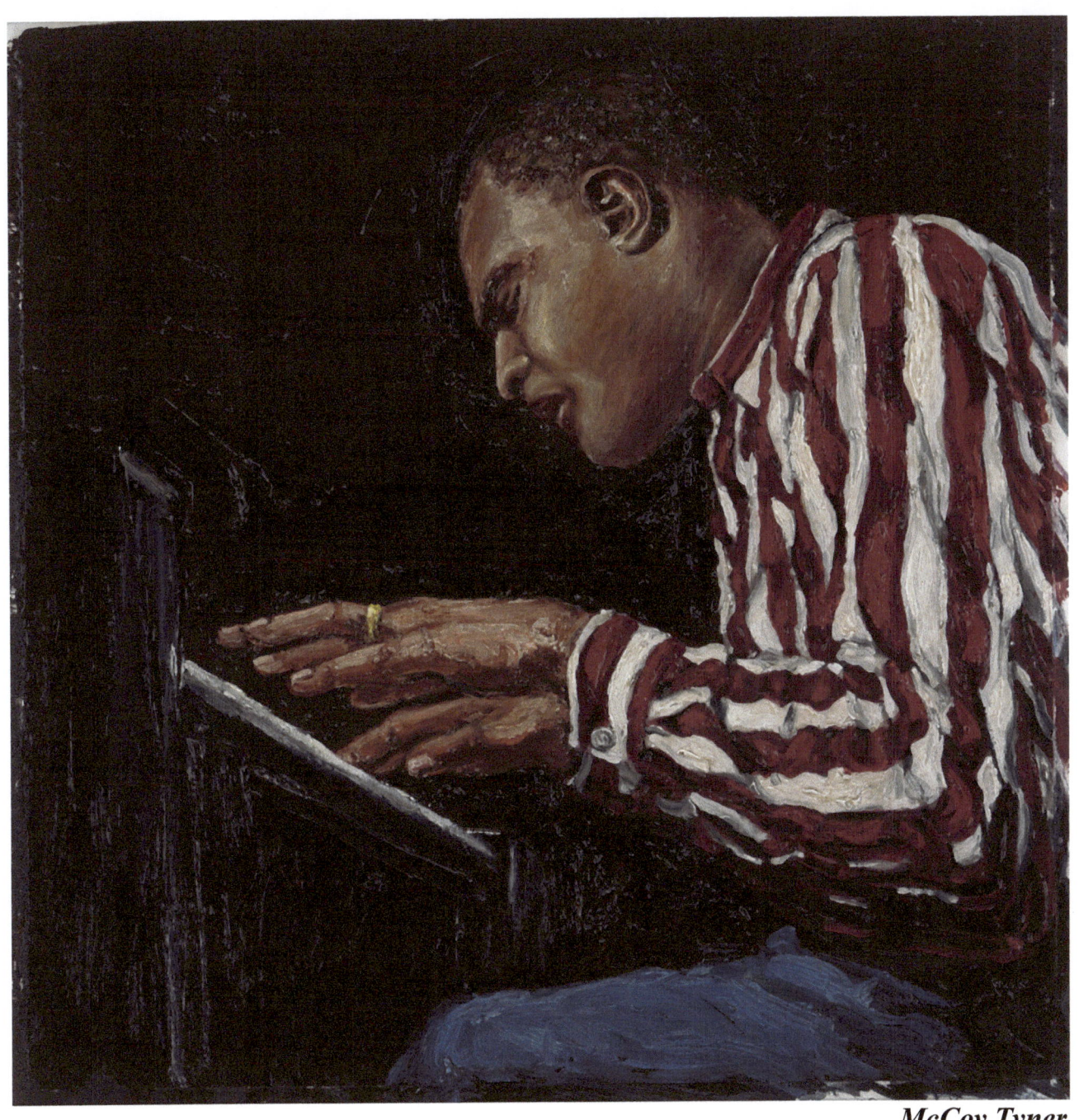

McCoy Tyner

I start in the middle of a sentence and move both directions at once. I'm into scales right now.
--John Coltrane

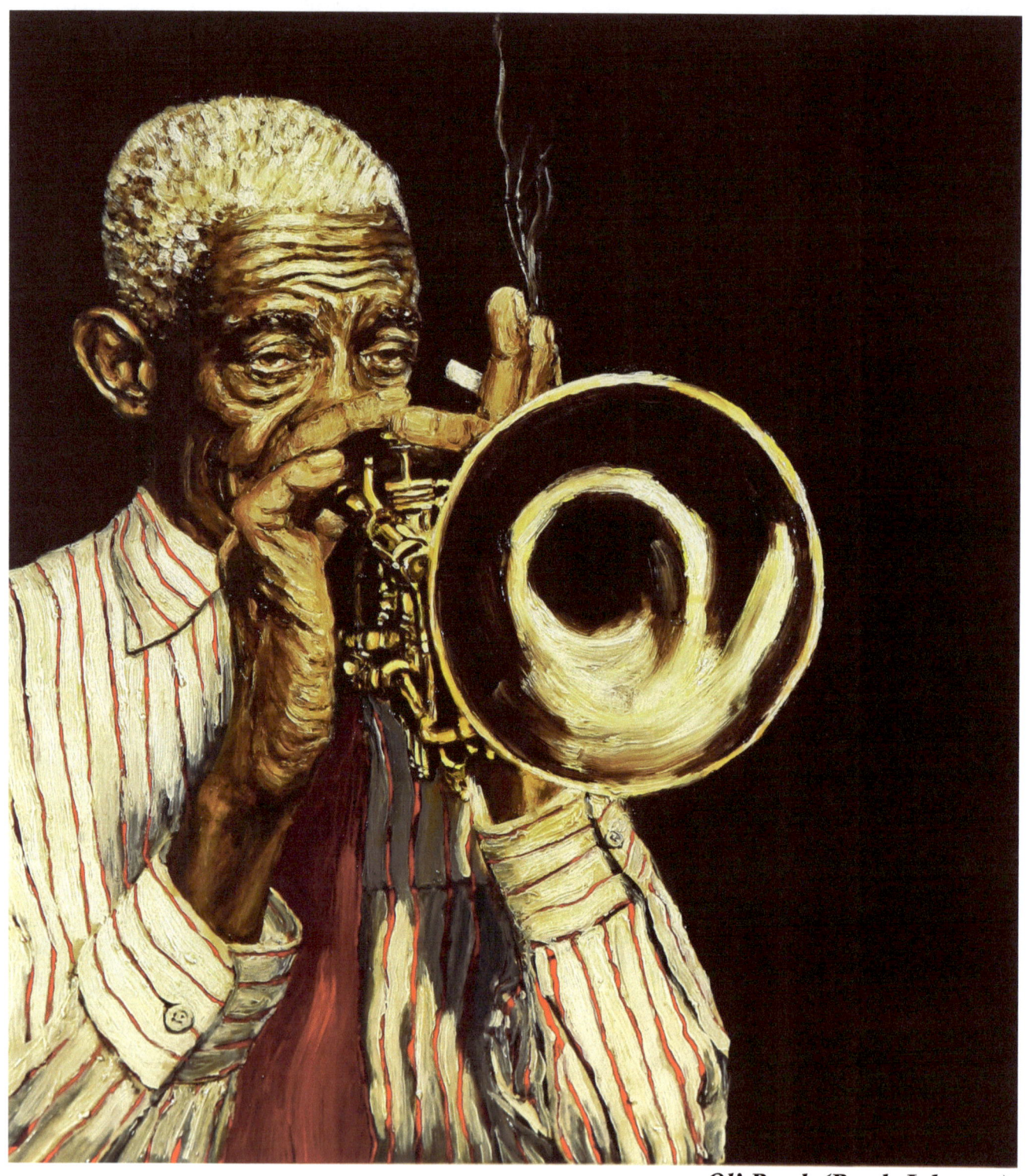

Ol' Bunk (Bunk Johnson)

New Orleans is the only place I know of where you ask a little kid what he wants to be; he says a musician.
> --Alan Jaffee

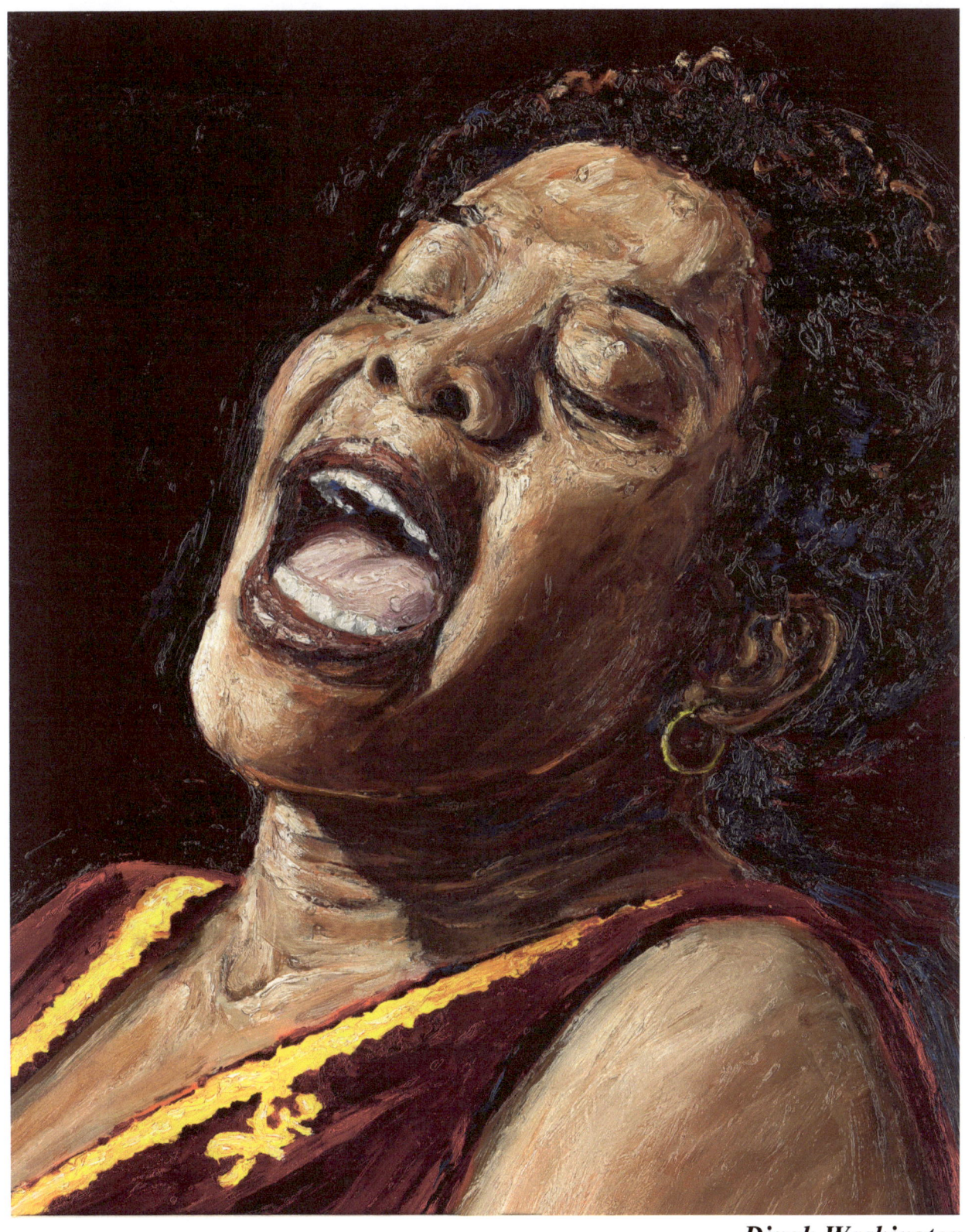

Dinah Washington

Blues is to jazz what yeast is to bread—without it, it's flat.
 --Carmen McCrae

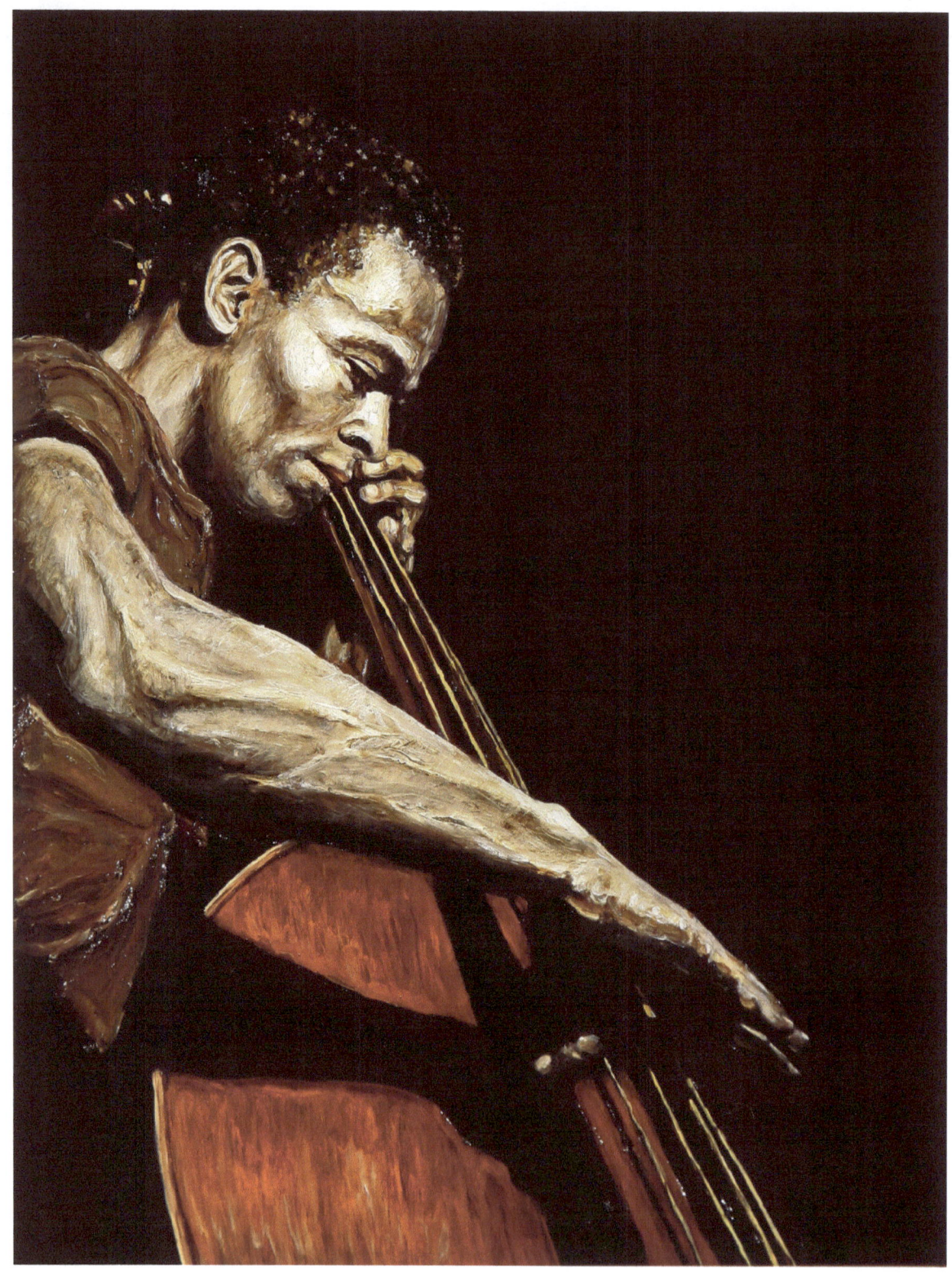

Cecil McBee

Life is like music; it must be composed by ear, feeling and instinct, not by rule.

--Samuel Butler

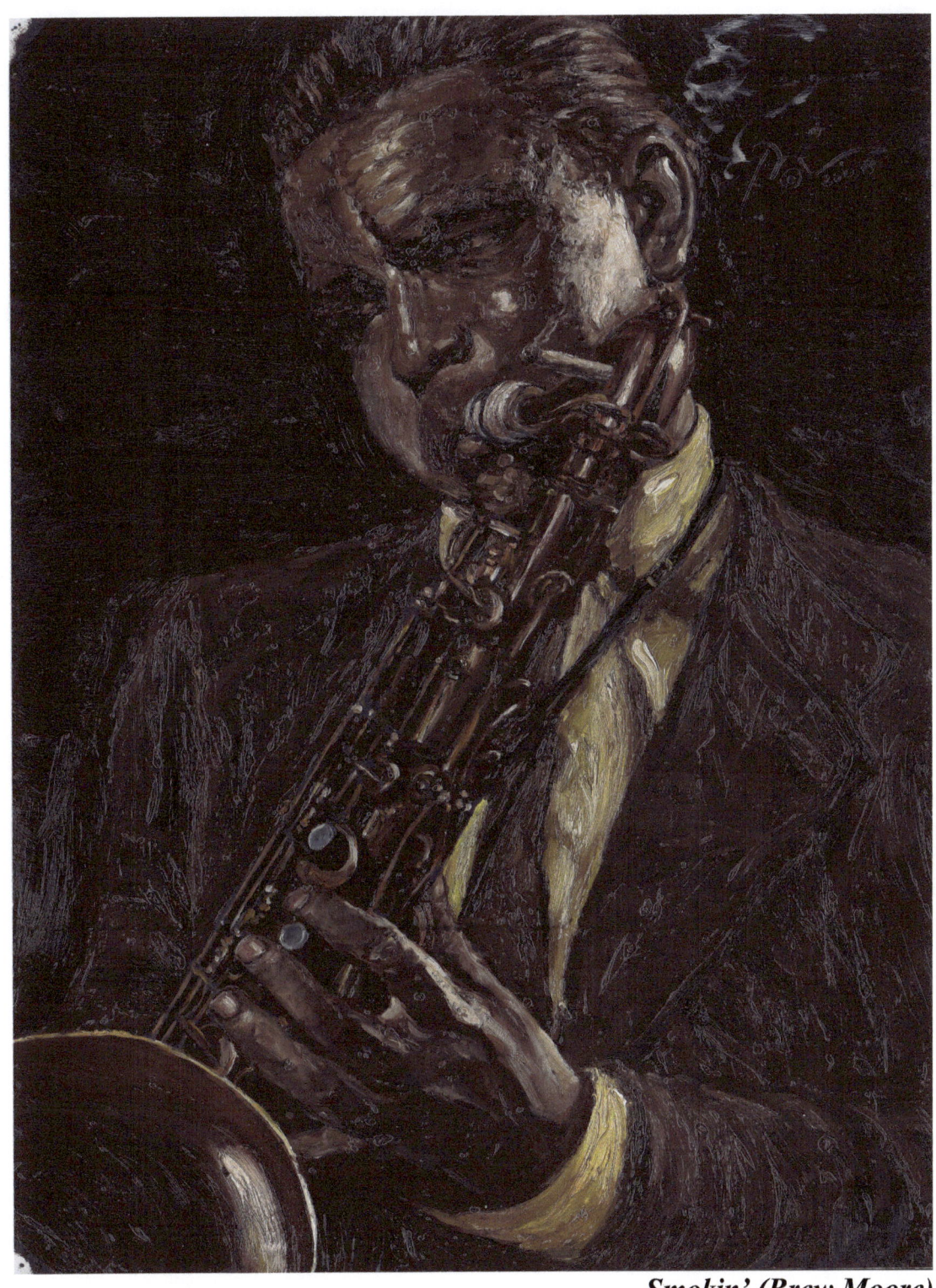

Smokin' (Brew Moore)

Jazz does not belong to one race or one culture, but is a gift that America has given to the world.

 --Ahmad Alaadeen

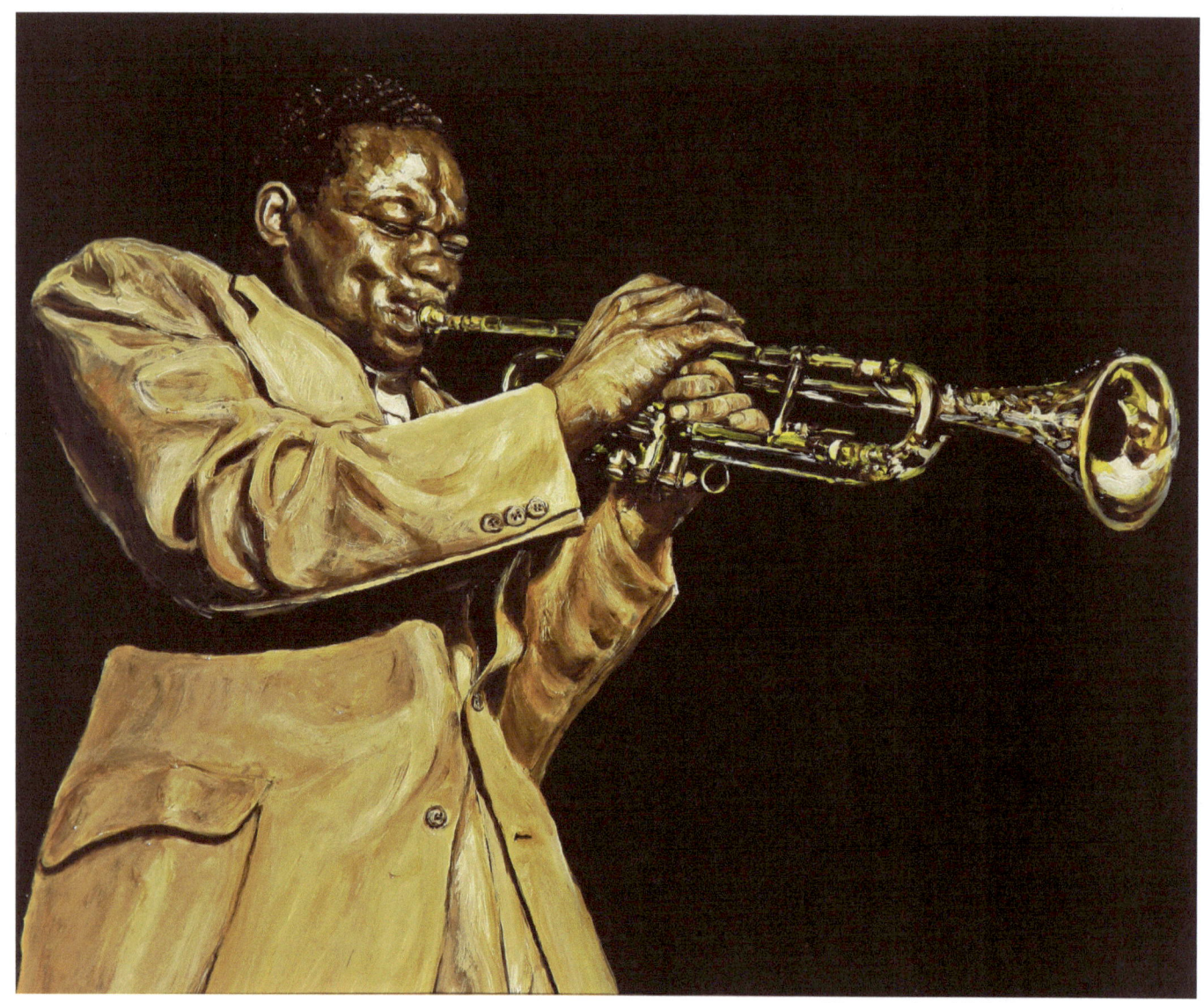

Brownie (Clifford Brown)

Clifford

How can we not remember Clifford?
That sweet trumpet tone
A brilliant future denied
Recalling his genius on re-mastered recordings
(With or without strings)
His brilliance lives.
"Yes, I remember Clifford still."

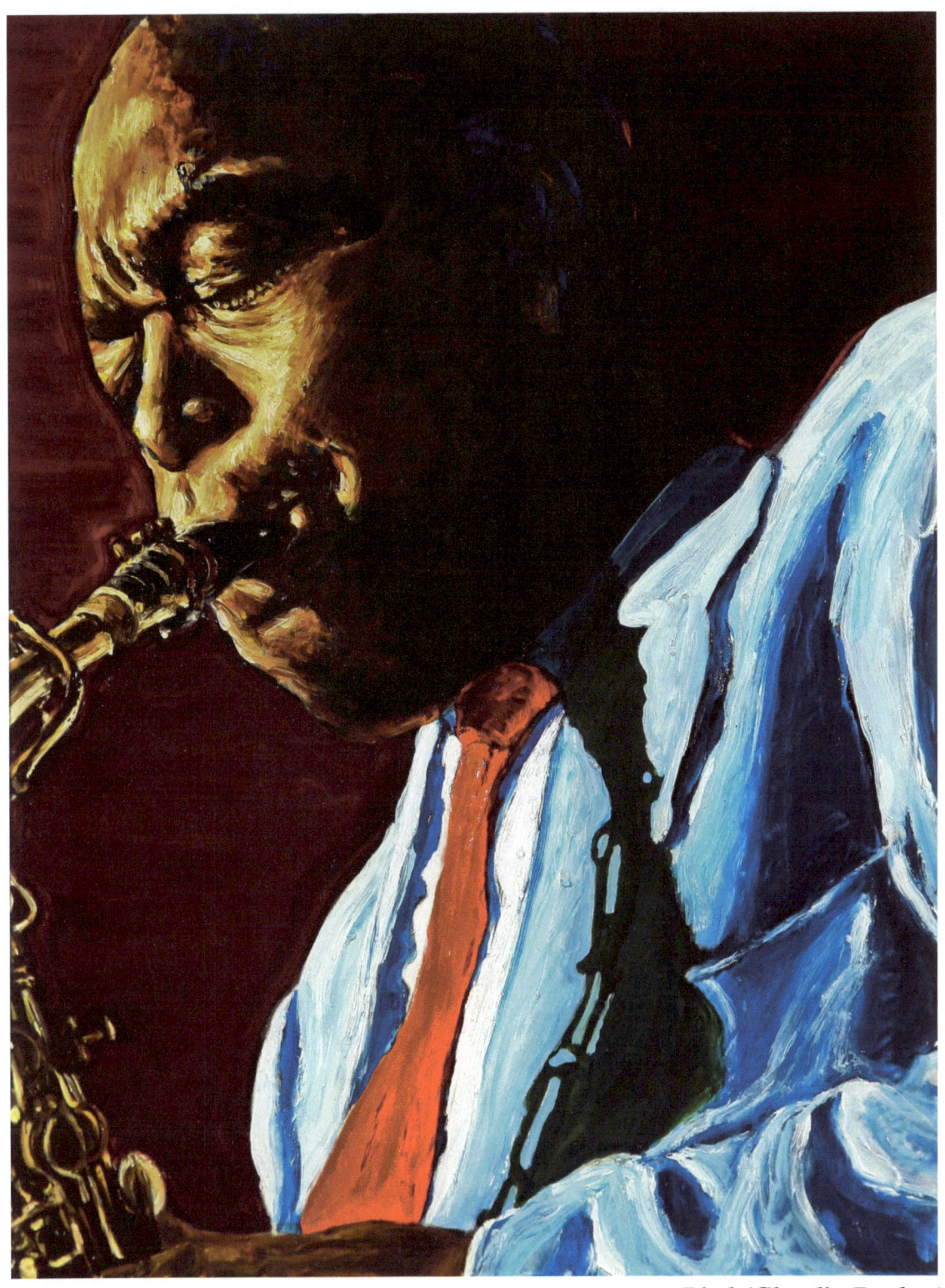

Bird (Charlie Parker)

I'm very glad to have met you. I like your playing very much.
<div style="text-align: right">--Charlie Parker to Jean-Paul Sartre</div>

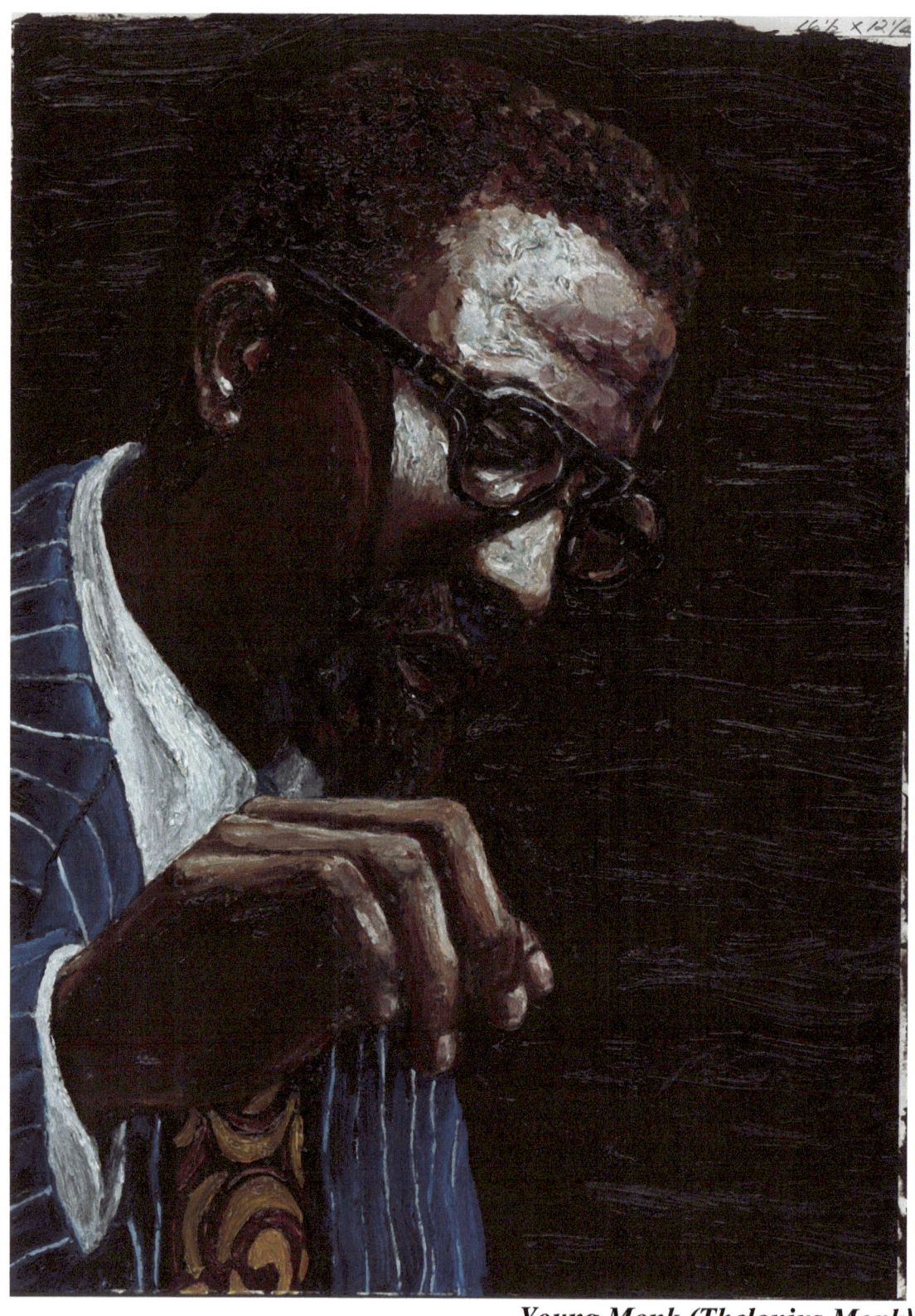

Young Monk (Thelonius Monk)

If you really understand the meaning of be-bop, you understand the meaning of freedom.
 --Thelonius Monk

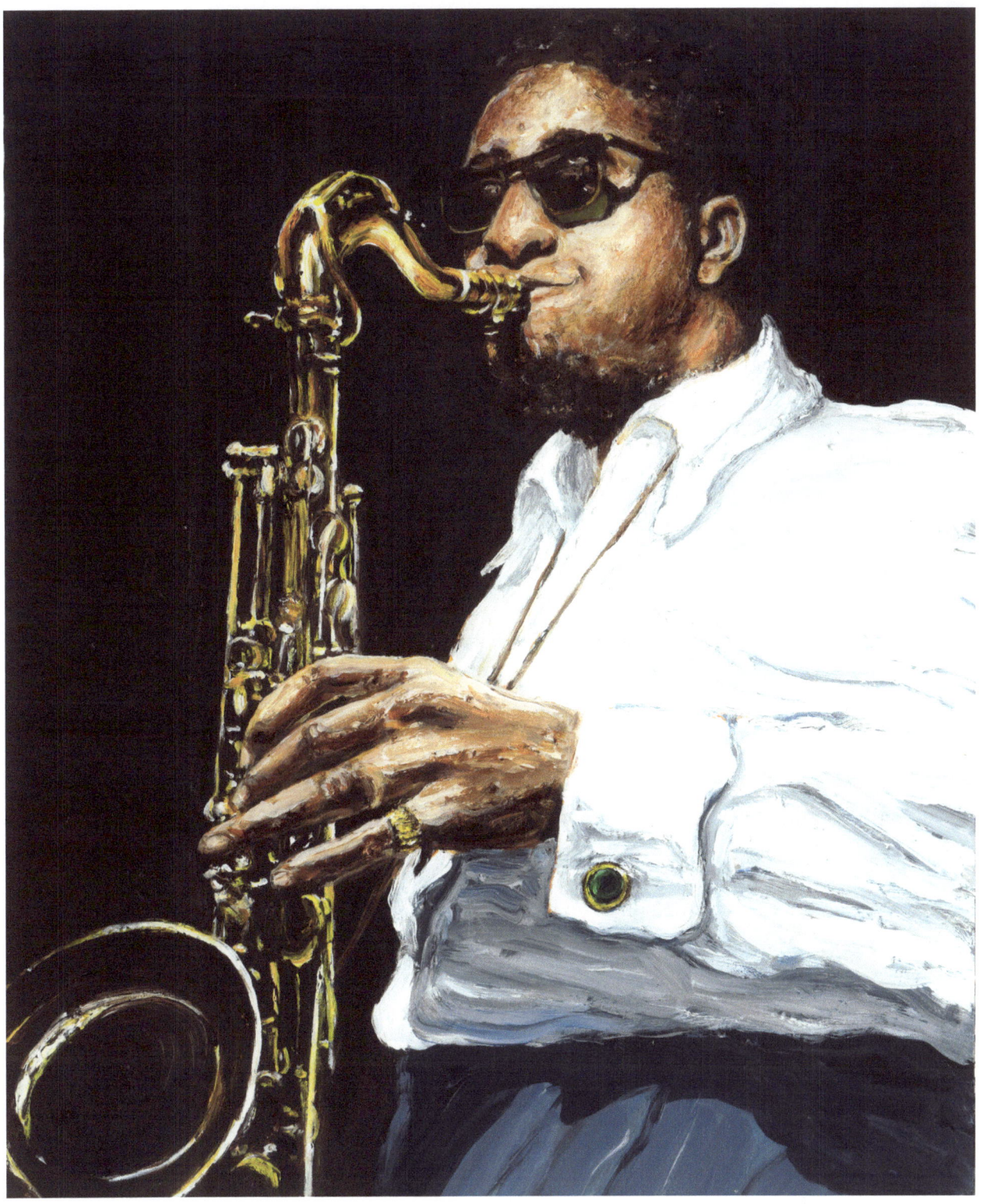

Sonny 2 (Sonny Rollins)

One very important thing I learned from Monk was his complete dedication to music. This was his reason for being alive. Nothing else mattered except music, really.
--Sonny Rollins

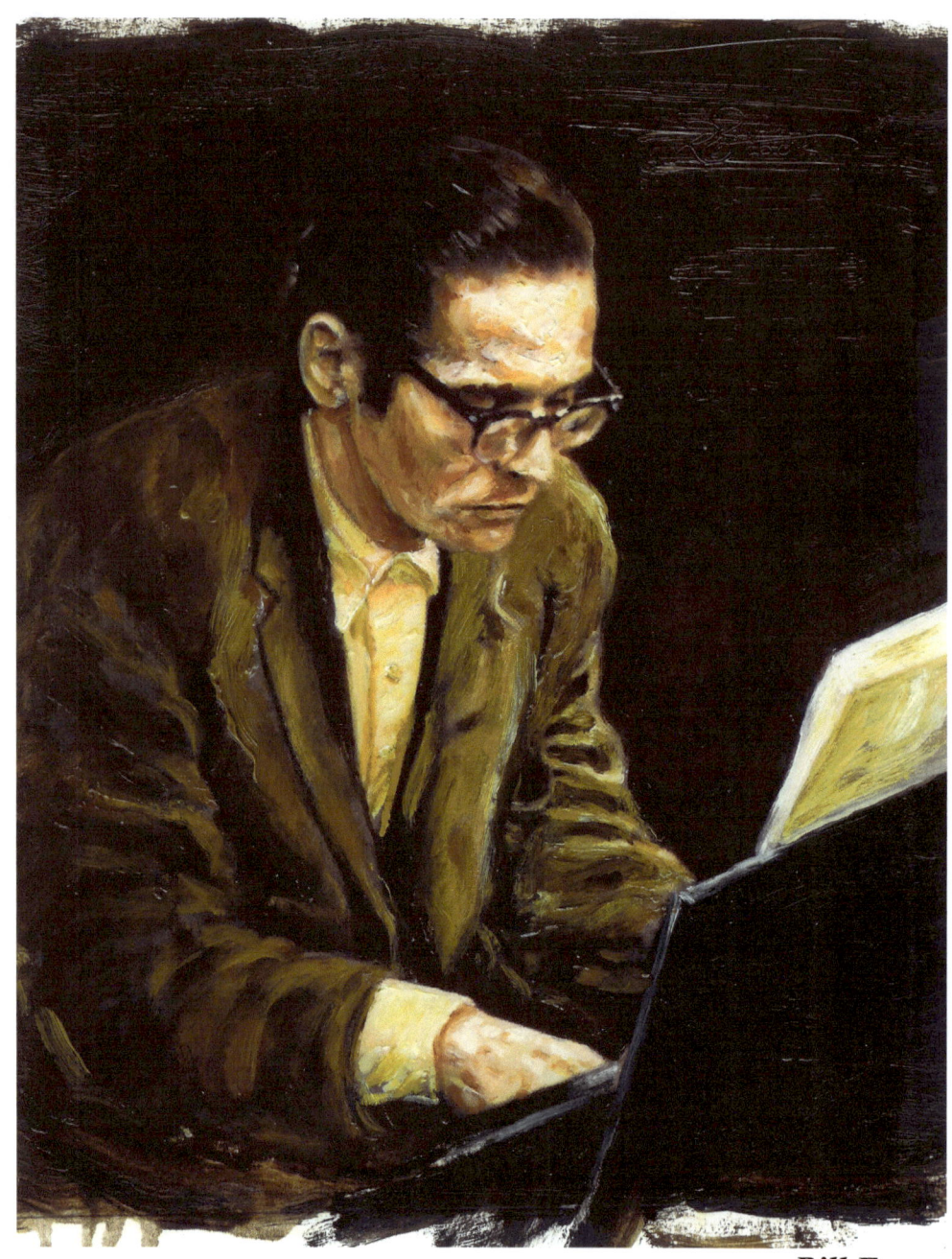

Bill Evans

Bill Evans

Gaunt, fragile
Cerebral, introspective
Hunched over, softly touching the keys
Hushed audience waiting for the next note—
What not played defined him.
Hemingway would have approved.

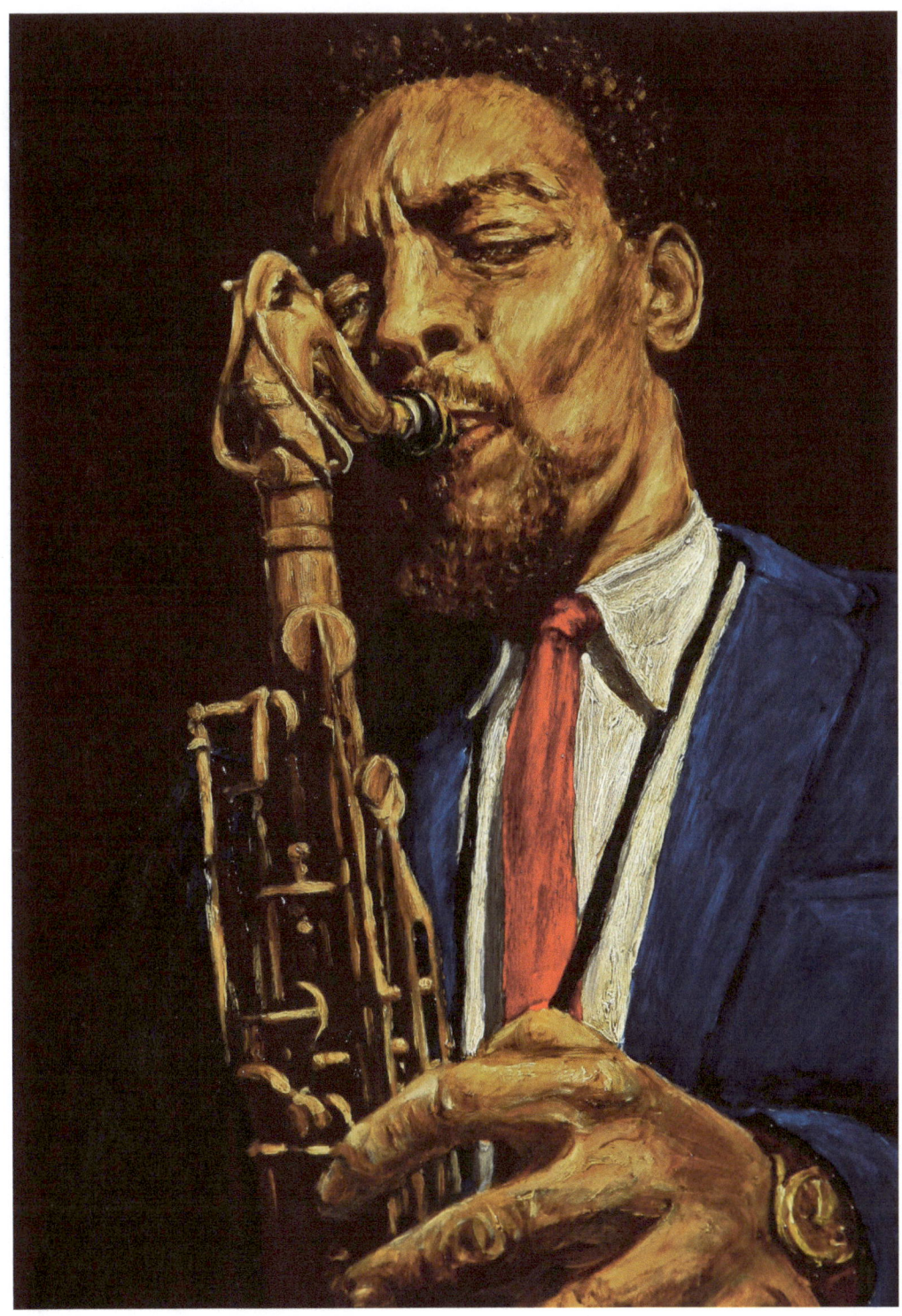

Sam Rivers

You've got to learn your instrument. Then you practice, practice, practice. And then, when you finally get up there on the bandstand, forget all that and just wail.

--Charlie Parker

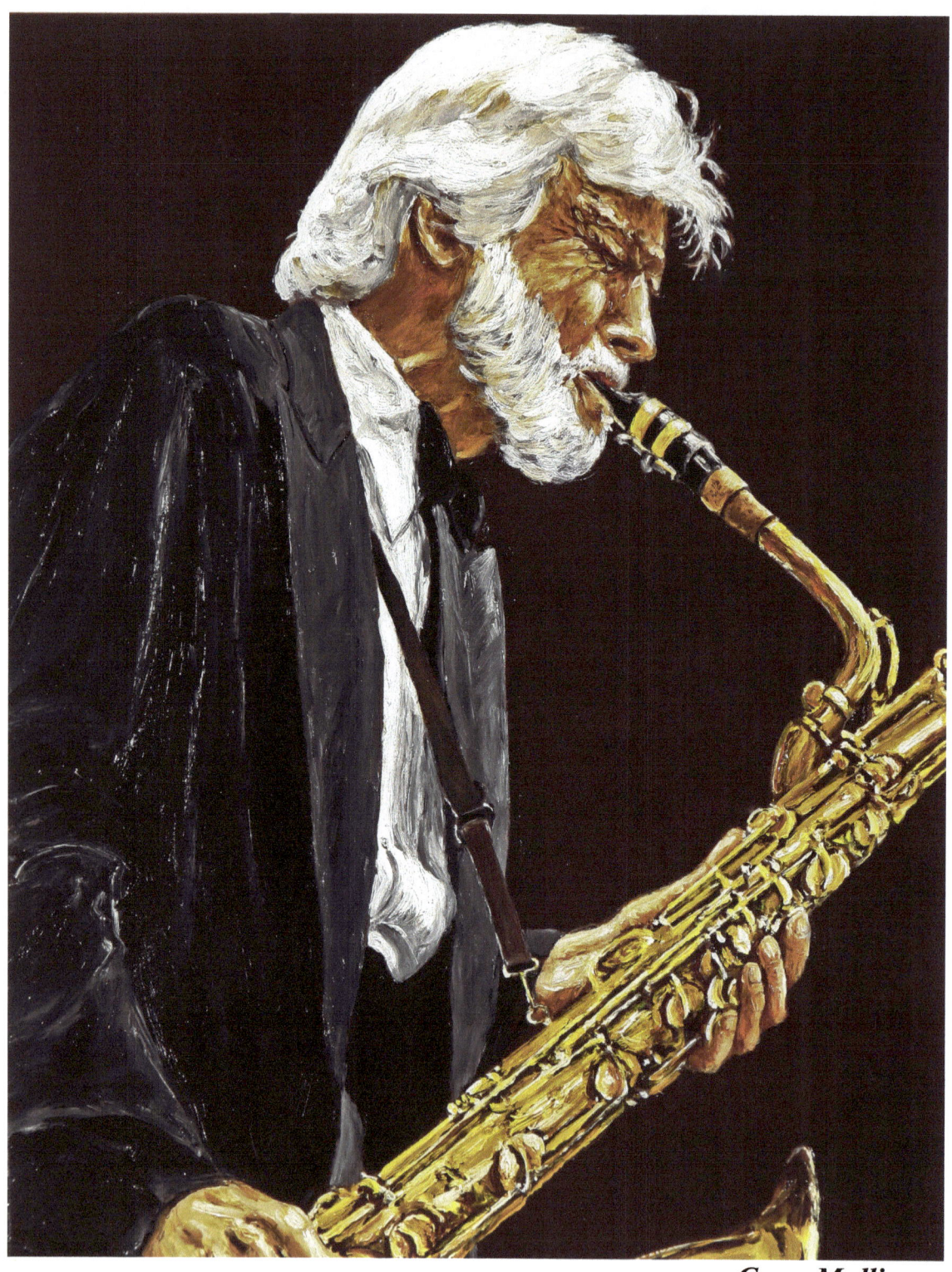

Gerry Mulligan

Jazz is the only music in which the same note can be played night after night but differently each time.
 --Ornette Coleman

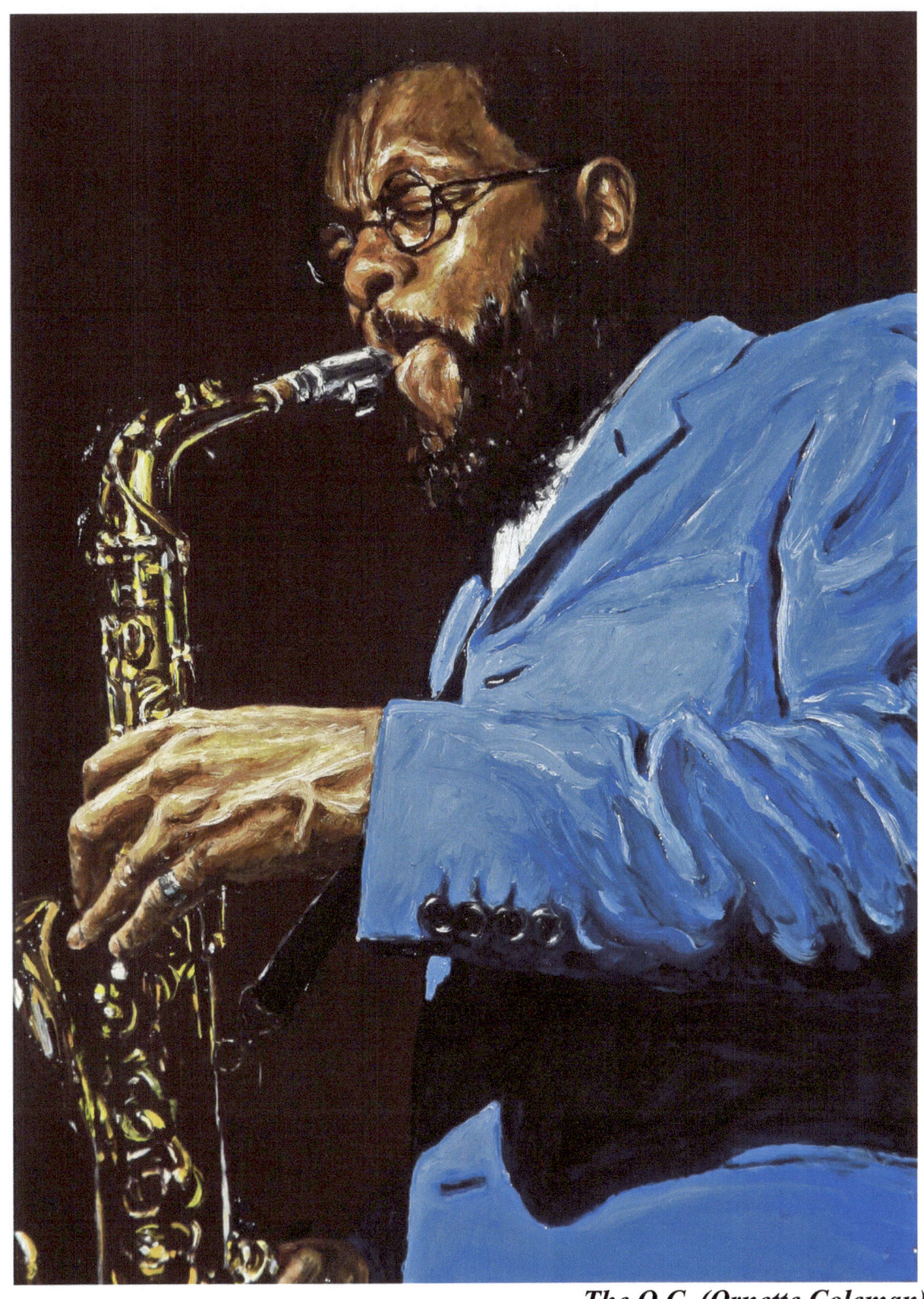

The O.C. (Ornette Coleman)

It was when I found out I could make mistakes that I knew I was on to something.
--Ornette Coleman

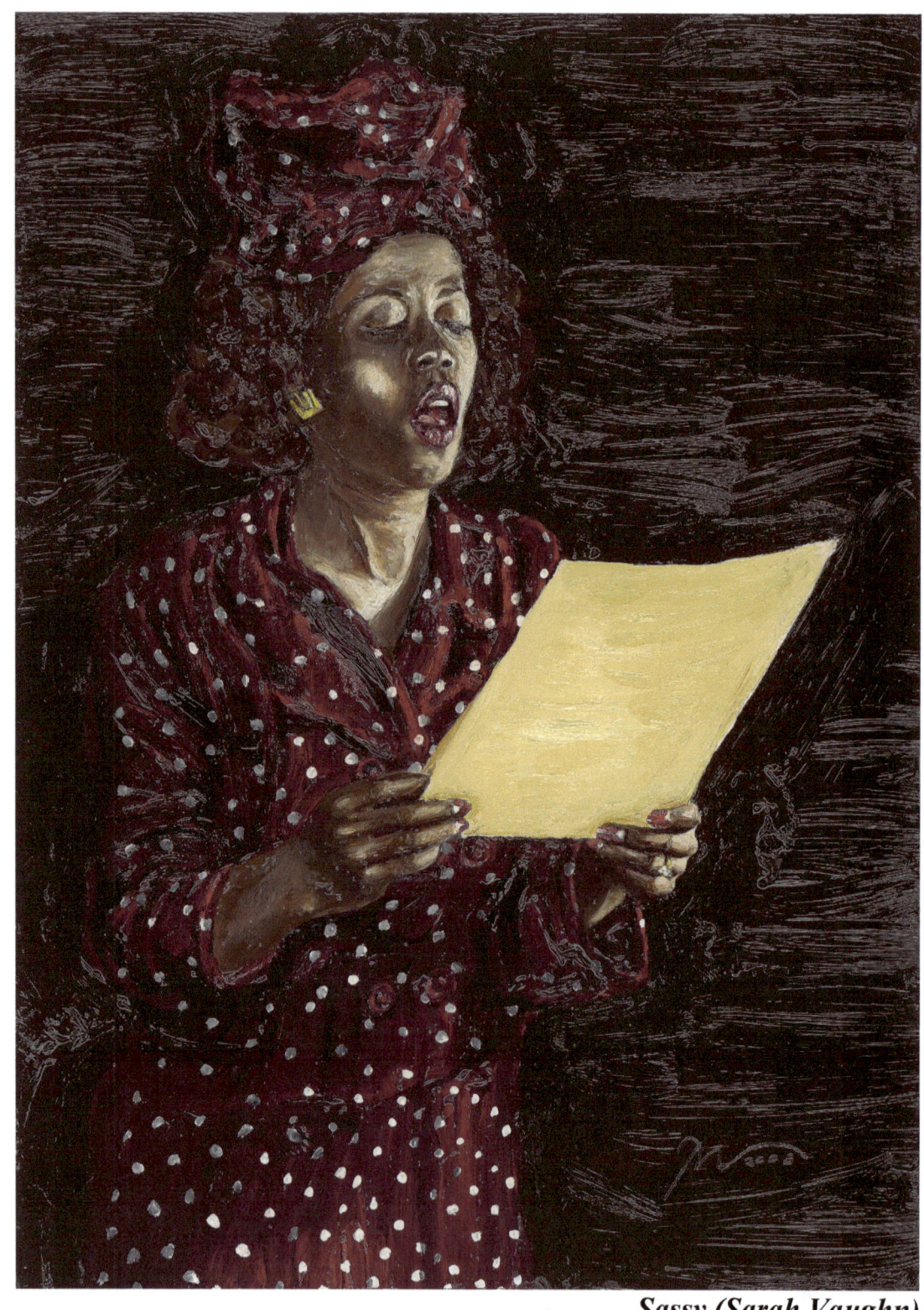

Sassy (Sarah Vaughn)

I hate straight singing. I have to change a tune to my own way of doing it. That's all I know.
--Billie Holliday

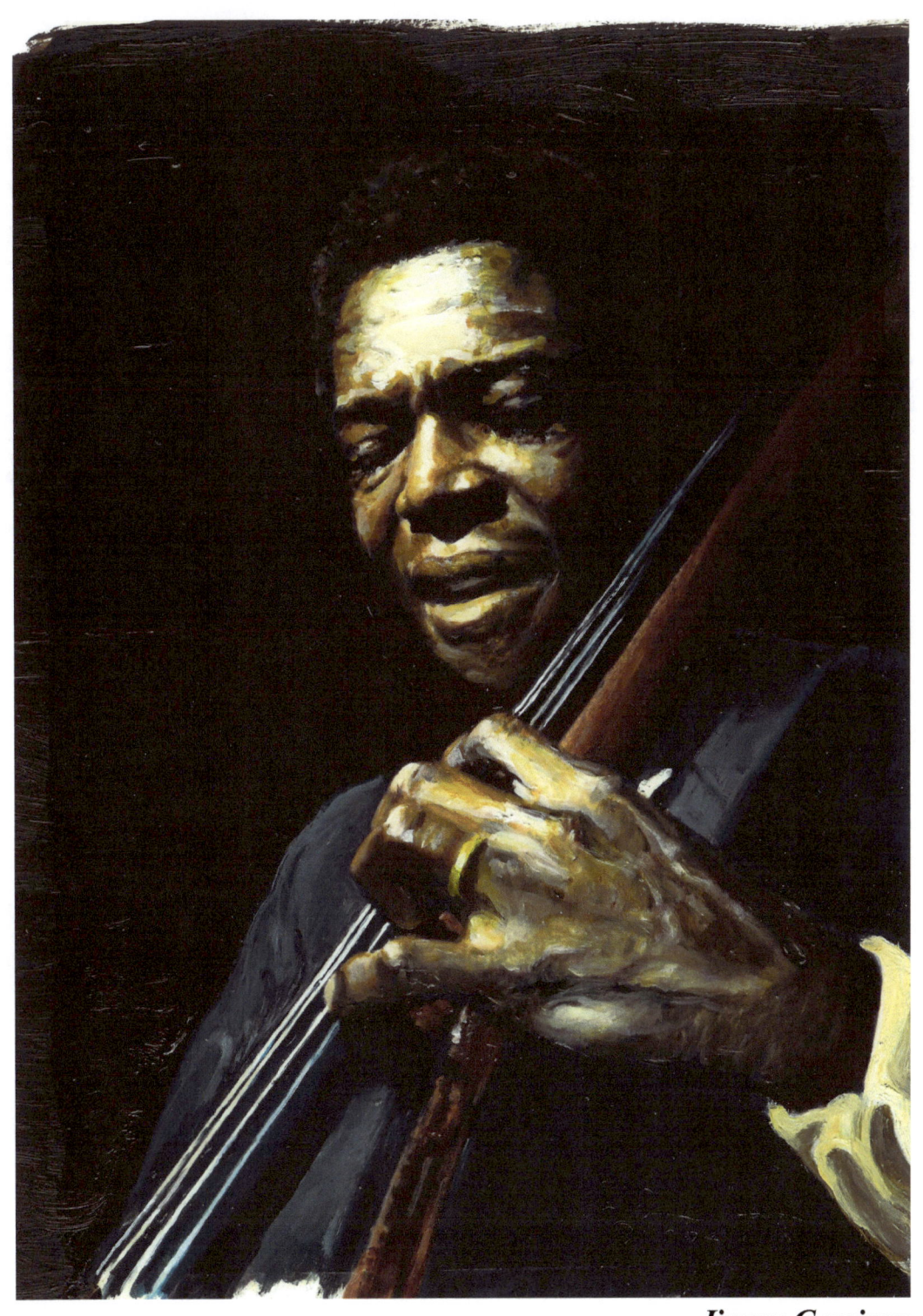

Jimmy Garrison

A good quartet is like a good conversation among friends, interacting to each other's ideas.
　　　　　　　　　　　　　　　　　　　　　　　　　　　　　　--Stan Getz

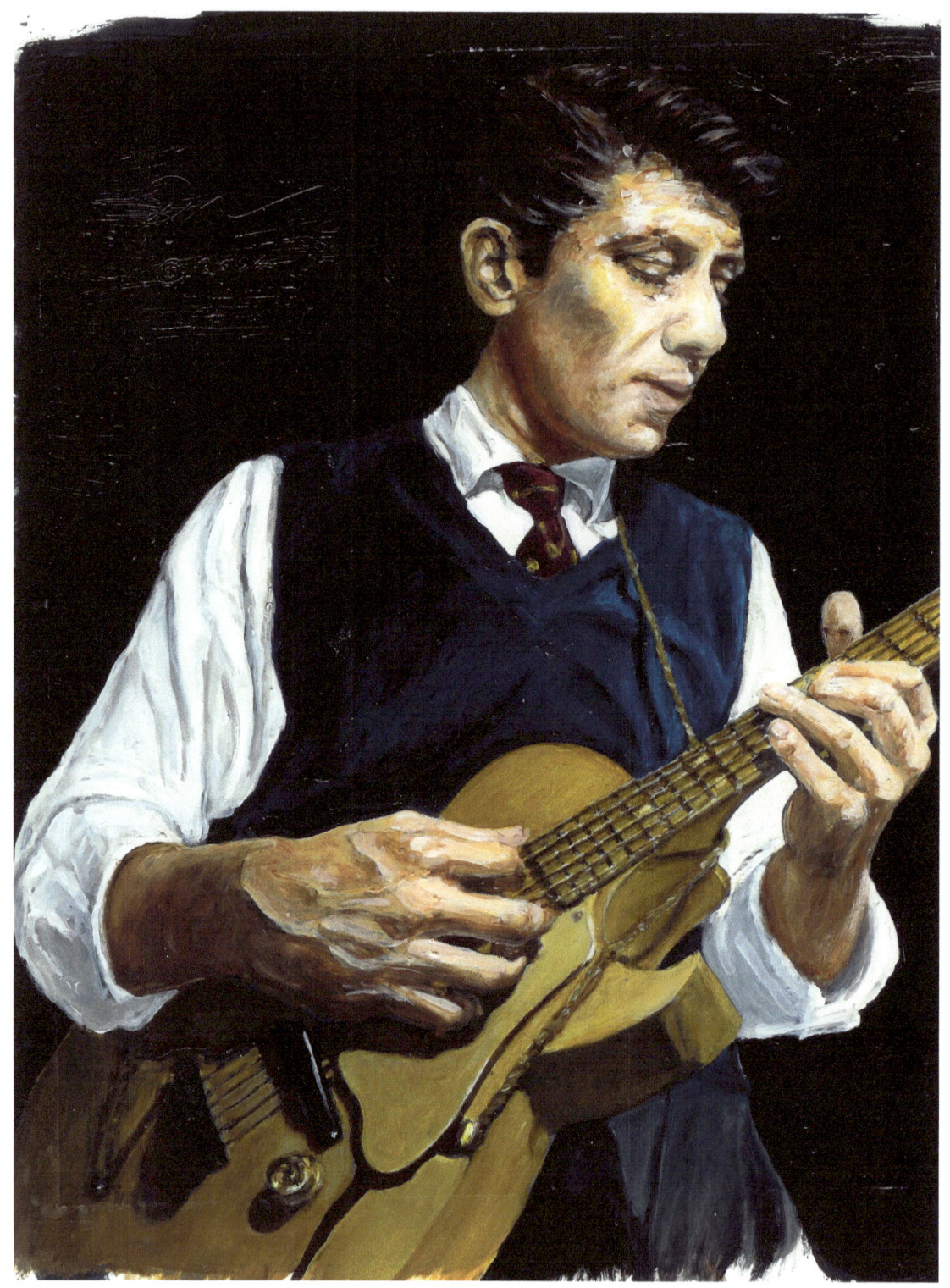

Tal Farlow

Making the simple complicated is commonplace; making the complicated simple, awesomely simple, that's creativity.
　　　　　　　　--Charles Mingus

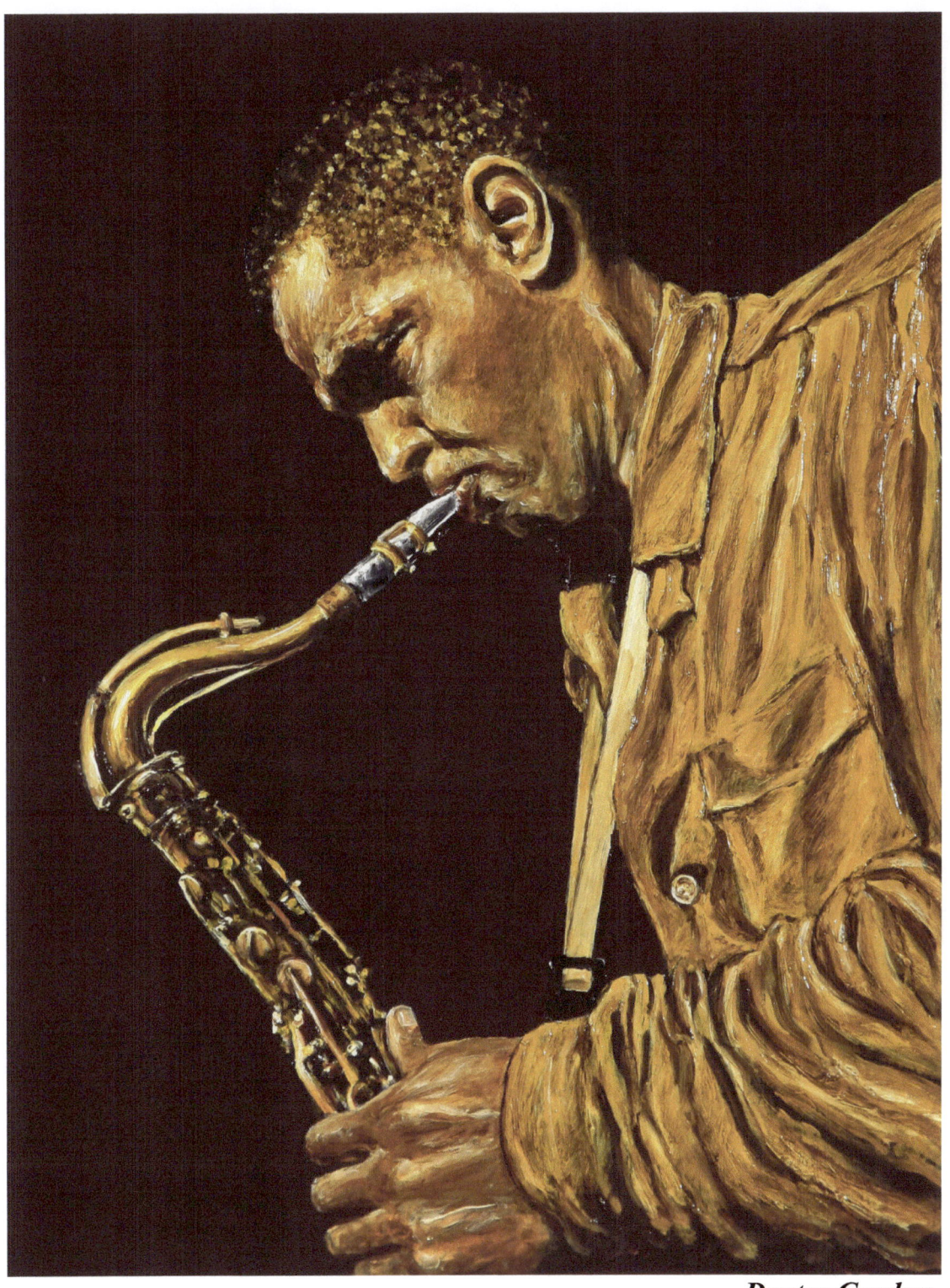

Dexter Gordon

I hope we left you with something to put under your pillow.
 --Dexter Gordon

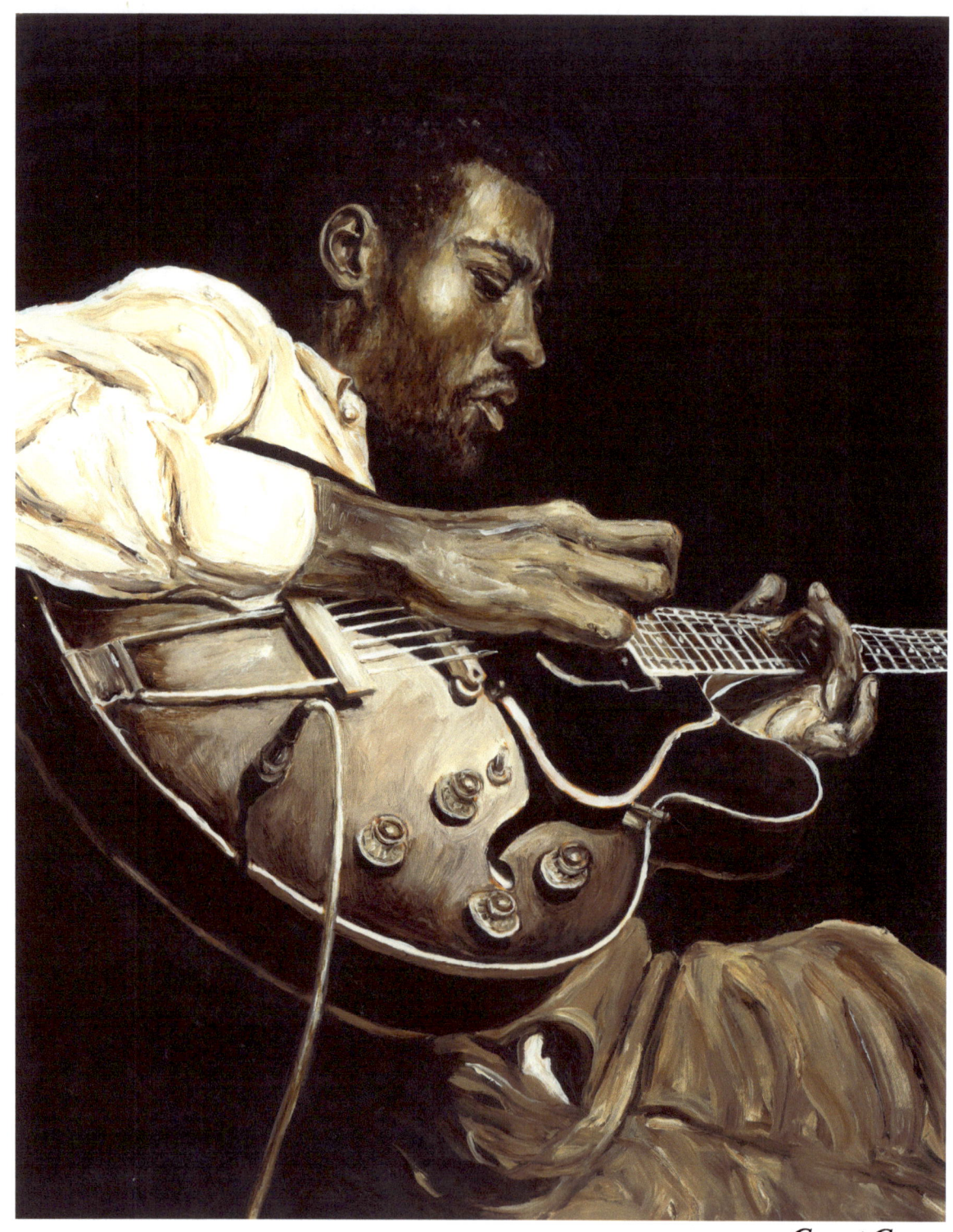

Grant Green

Wes Montgomery played impossible things on the guitar because it was never pointed out to him that they were impossible.
 --Ronnie Scott

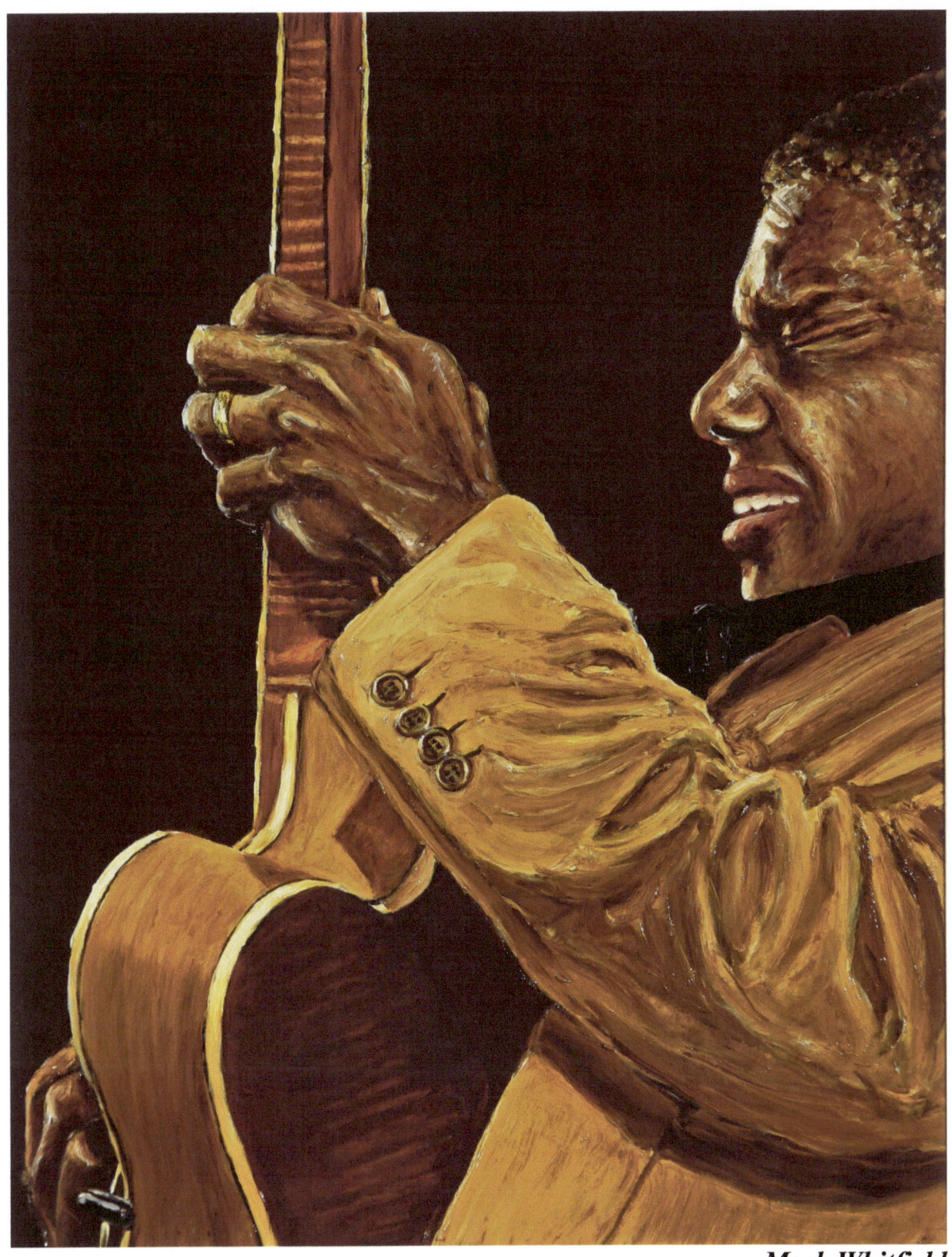

Mark Whitfield

Let your life be your music and let your music be your life.
　　　　　　　　　　　　　　　　　　--Kevin Eubanks

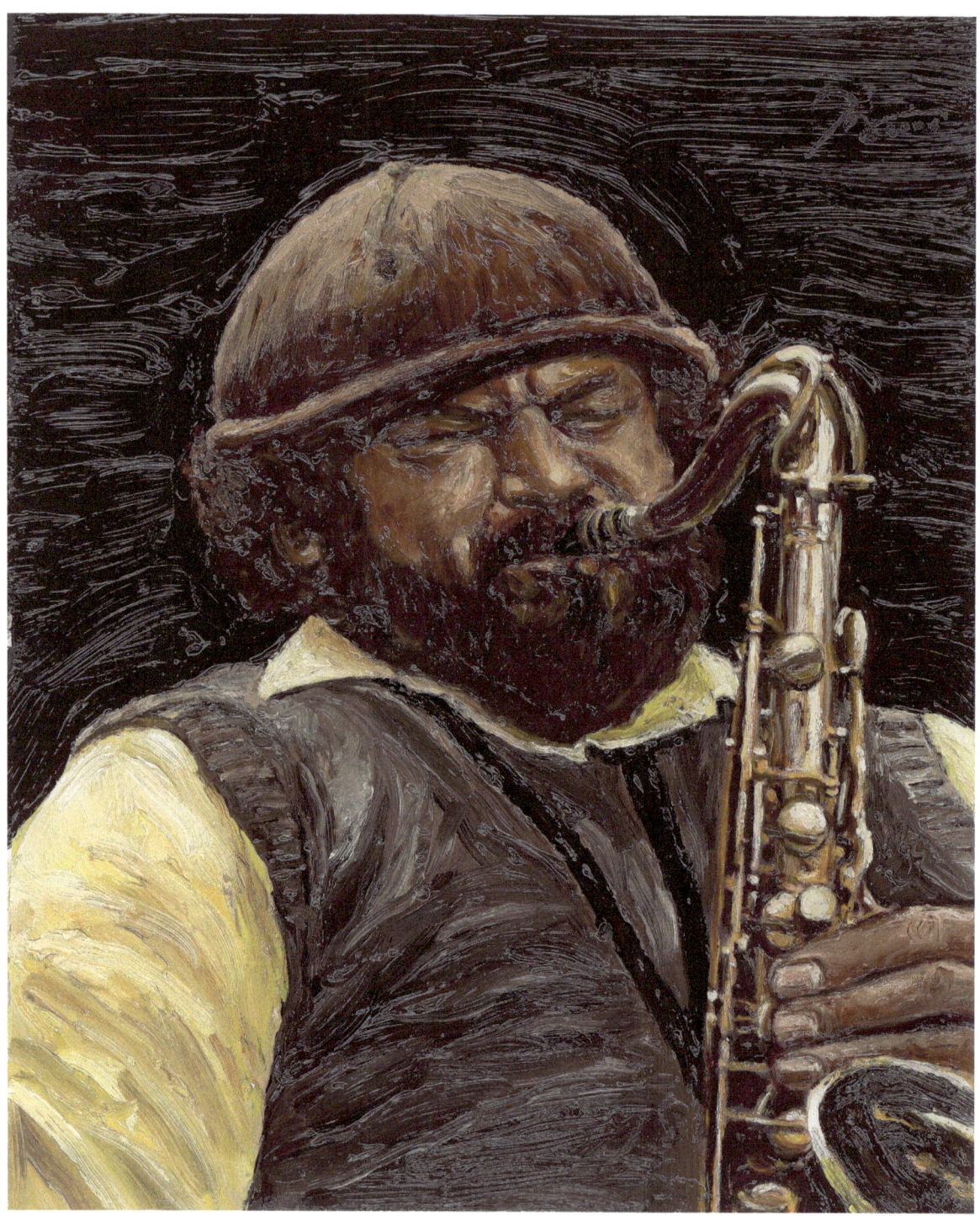

Straight Ahead (Sal Natisco)

In the midst of creating, a person is raised to another level of consciousness that doesn't have that much to do with everyday thinking. It's as if you could imagine life before there were words.
 --Charlie Haden

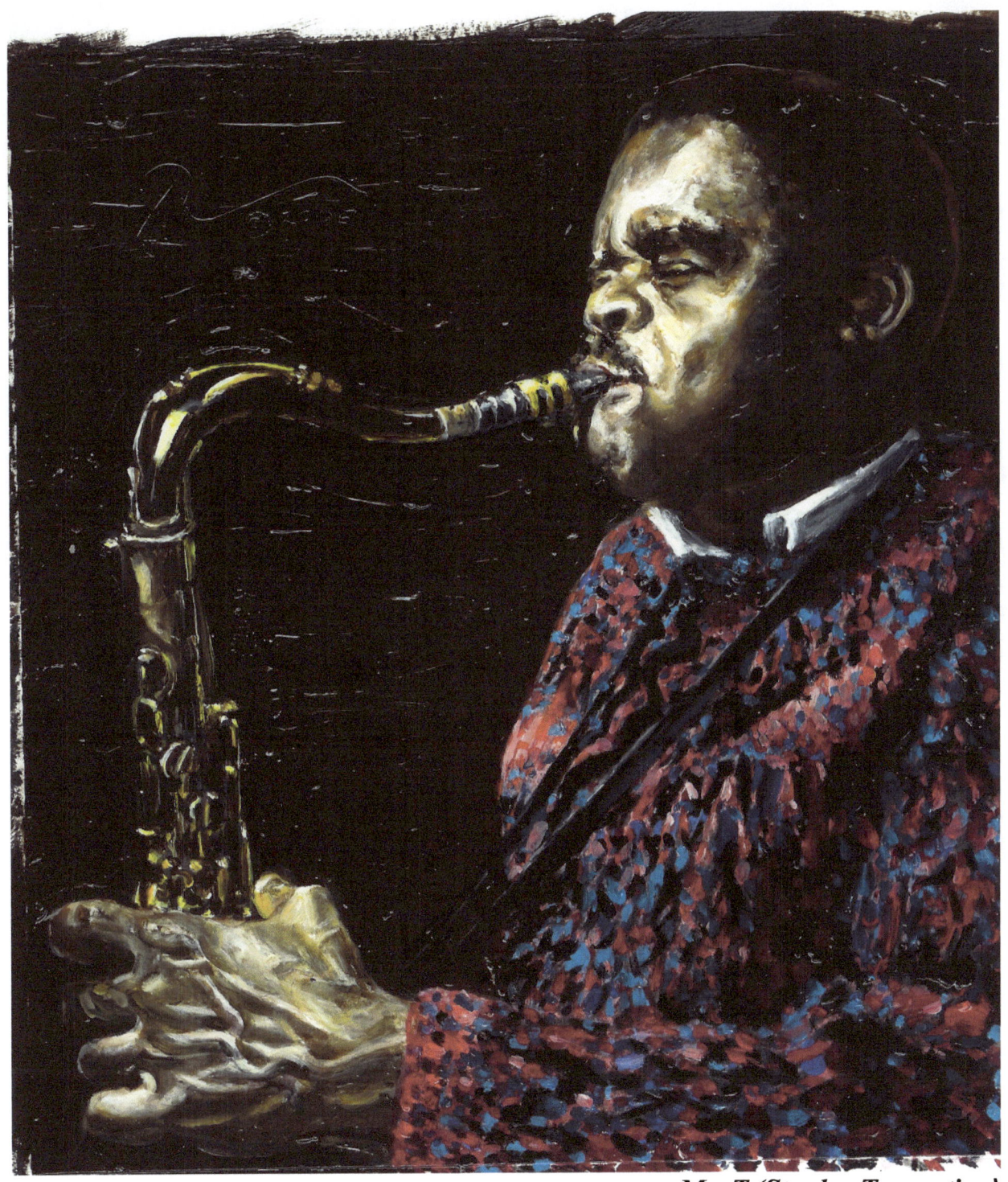

Mr. T (Stanley Turrentine)

The golden curves and gorgeous sound of the saxophone have blown throughout the world like a beautiful breeze, inspiring many to study its charms.
 --Tommy Smith

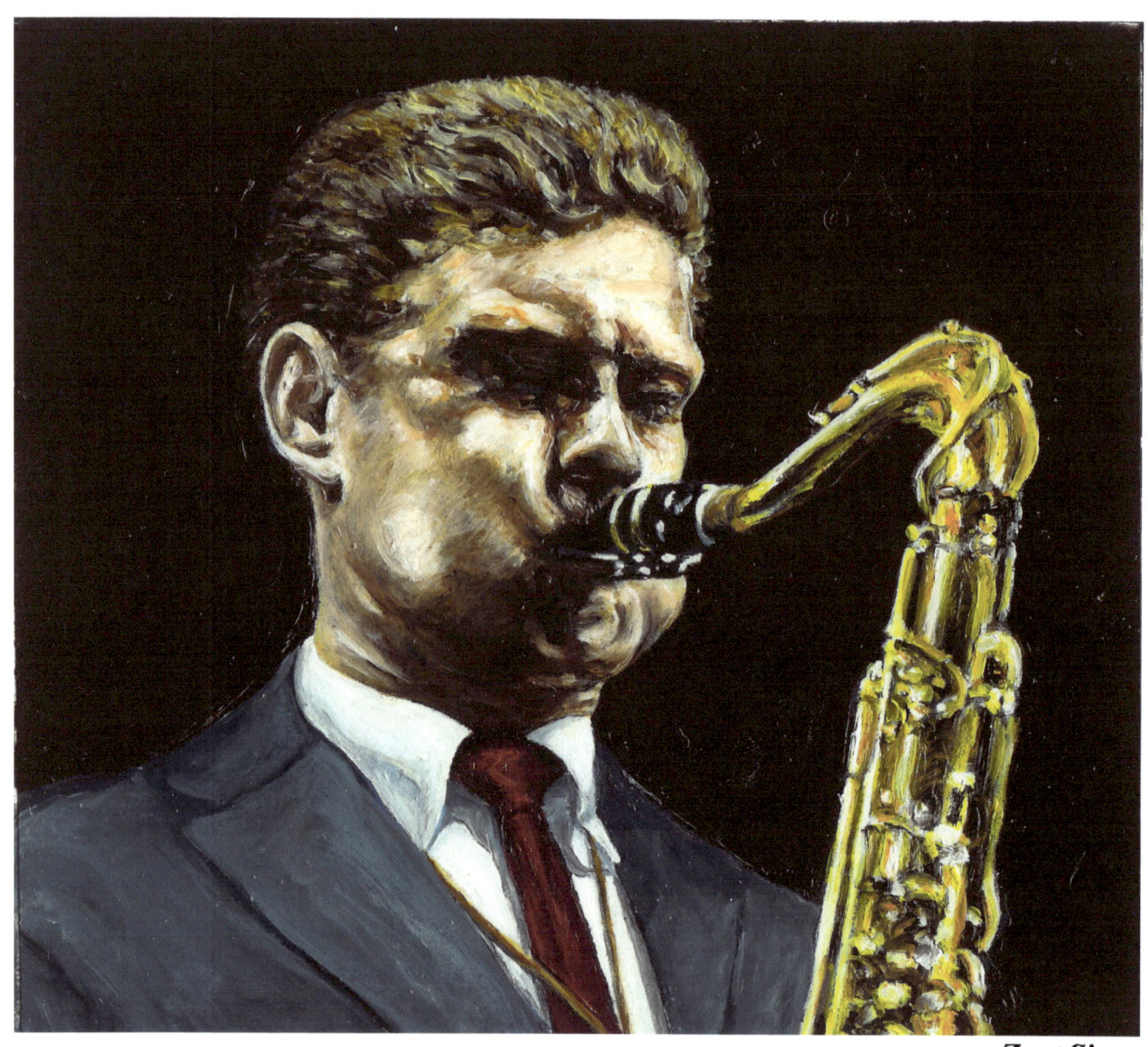

Zoot Sims

Music, for me, has always been a place where anything is possible—a refuge a magical world where anyone can go, where all kinds of people can come together, and anything can happen. We are limited only by our imaginations.

--Bill Frisell

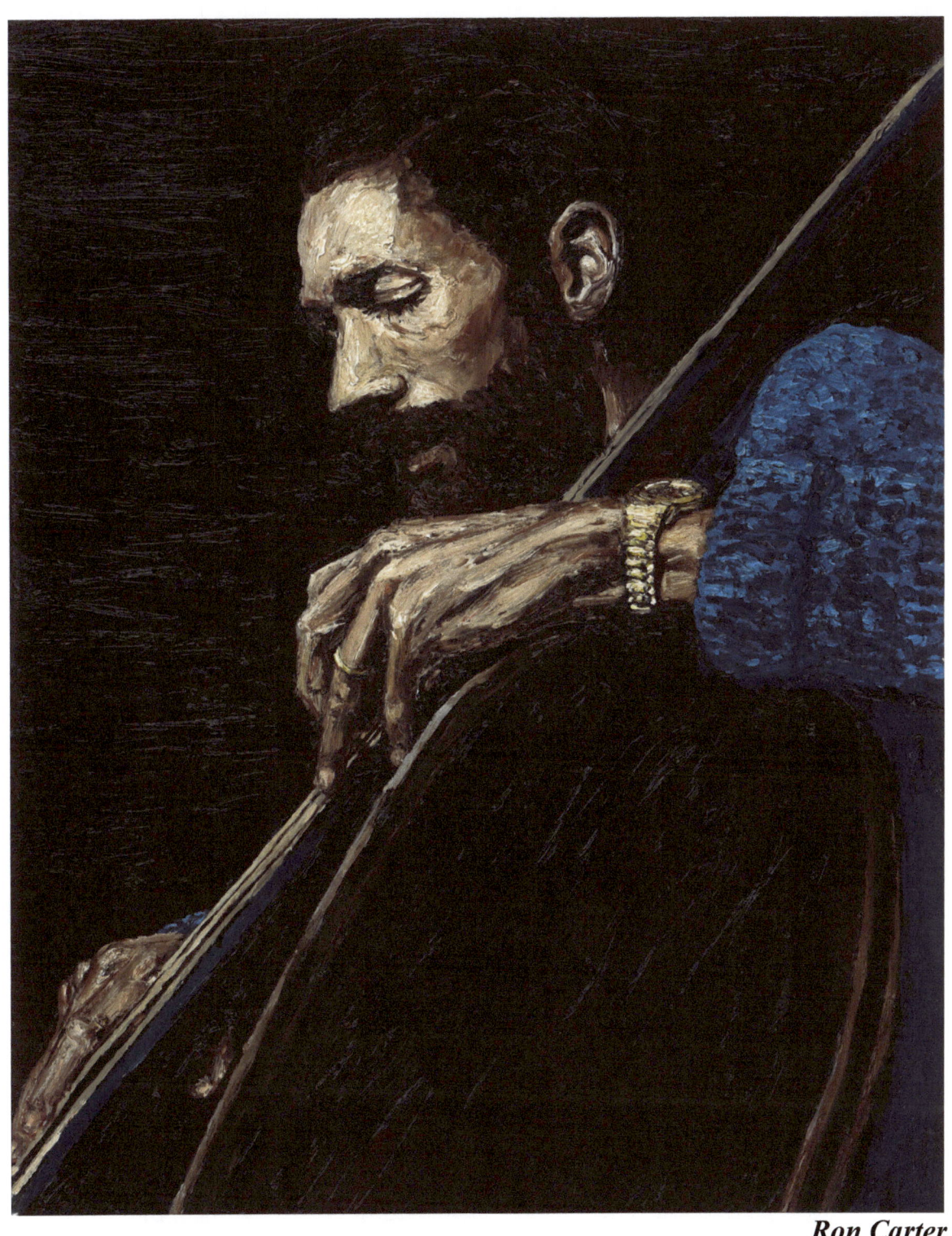

Ron Carter

Improvisation is the ability to talk to oneself.
 --Cecil Taylor

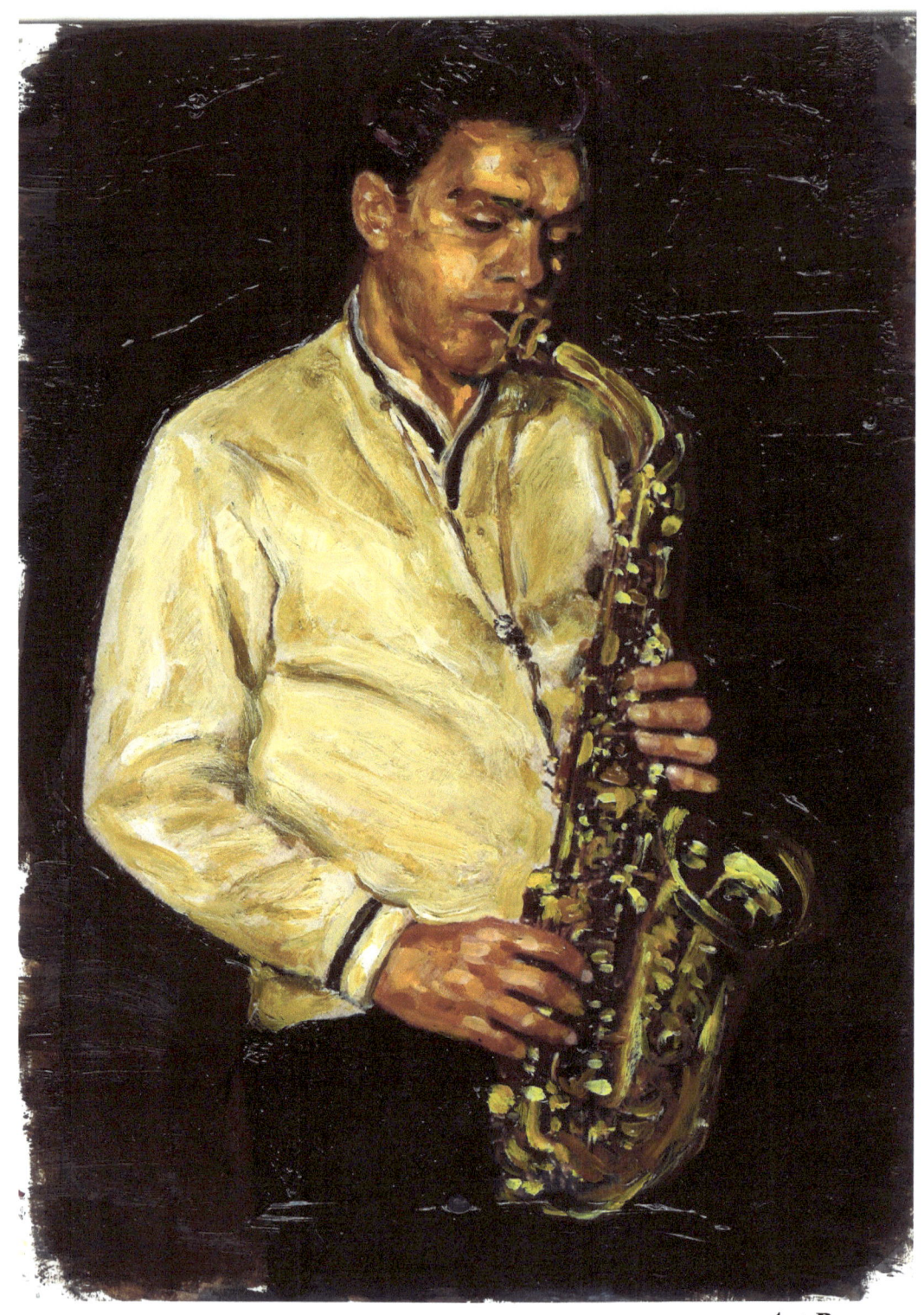

Art Pepper

One thing I like about jazz, kid, is that I don't know what's going to happen next.
　　　　　　　　　　　　　　　　　　　--Bix Beiderbecke

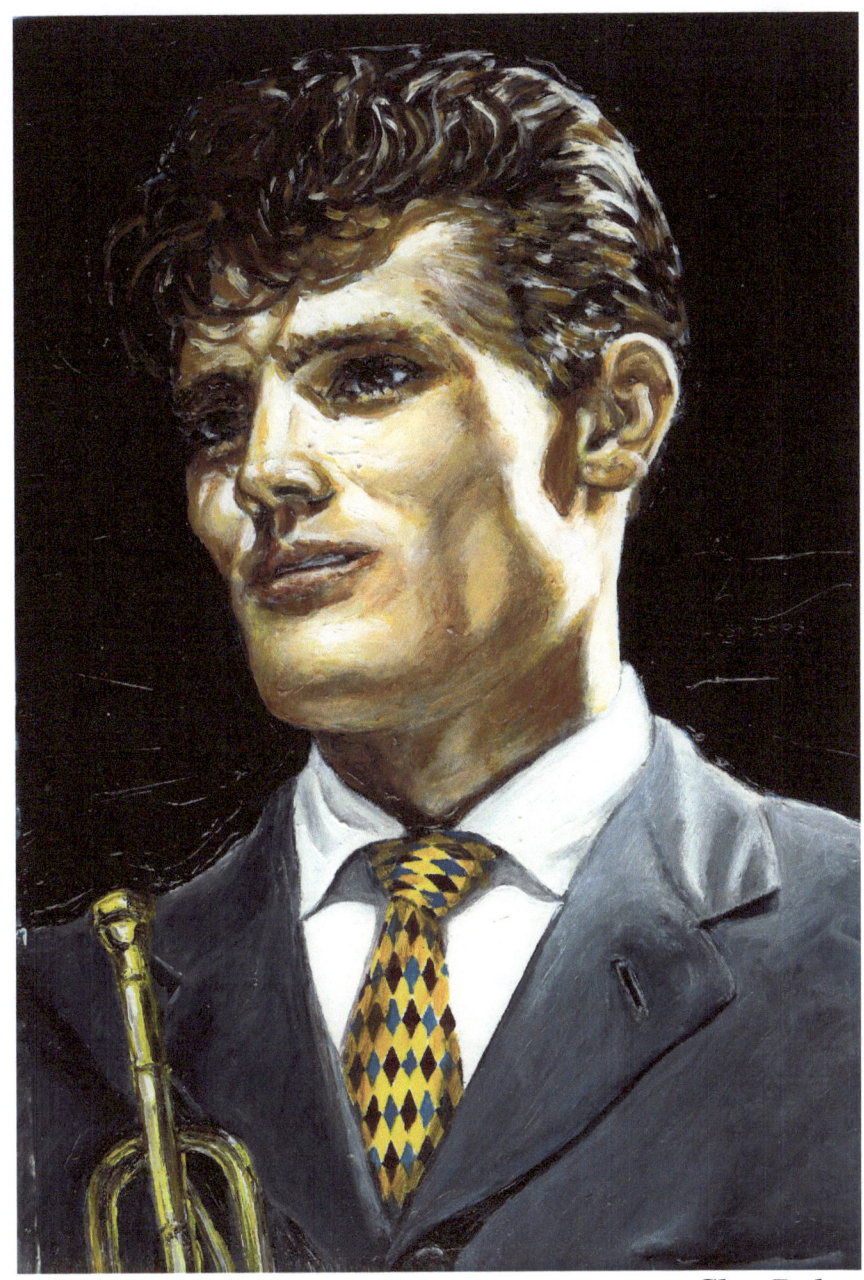

Chet Baker

Chet

My Funny Valentine and sweet-smelling smoke
Wafting over Sausalito rooftops
A trumpet player with combed back hair, red-eyed
High cheekbones, matinee-idol looks,
Almost pretty—

"Hi, I'm Chet. You like jazz?"
Even when he was lost
He could play that horn.

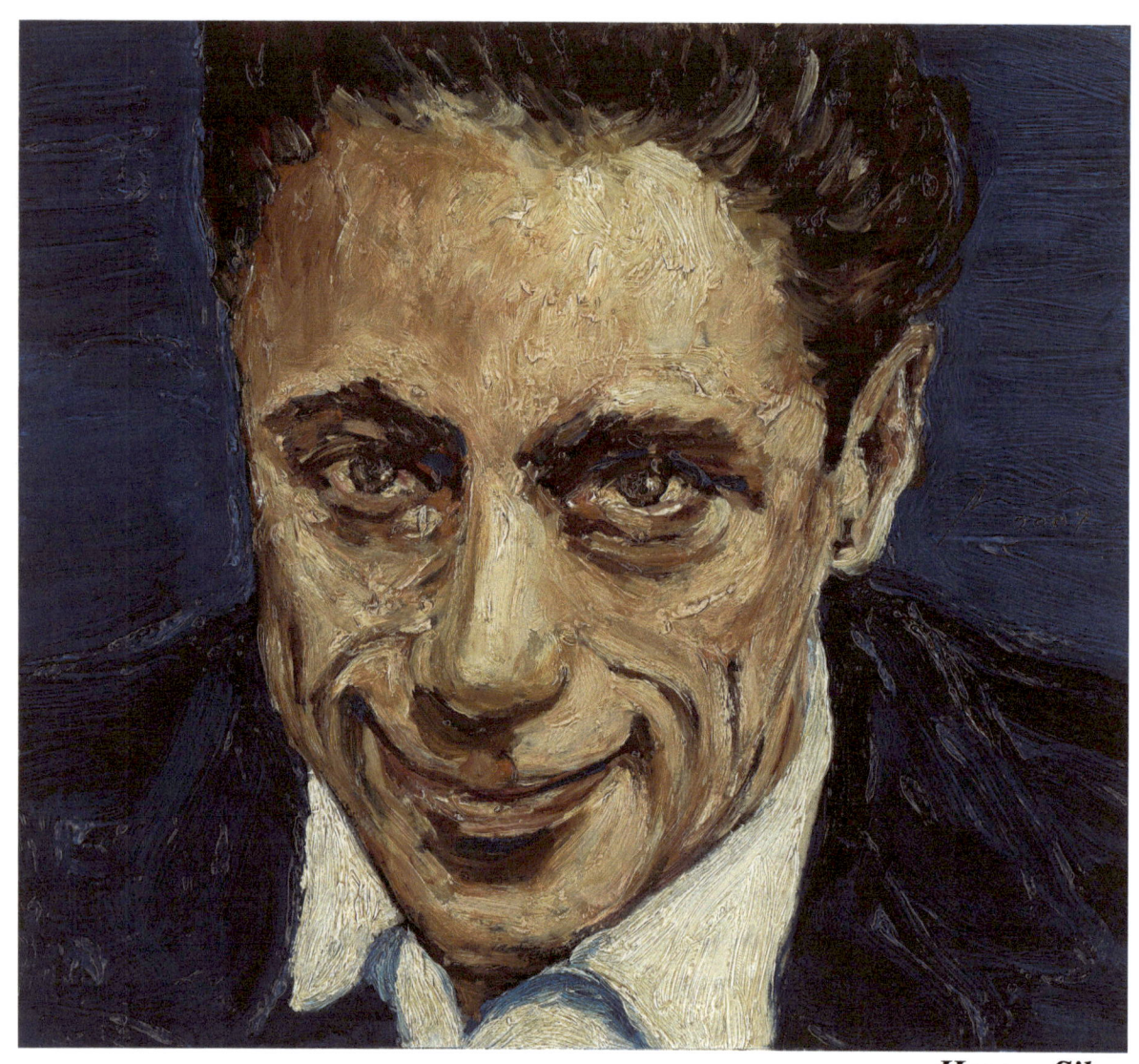

Horace Silver

It bugs me when people try to analyze jazz as an intellectual theorem. It's not it's feeling.
--Bill Evans

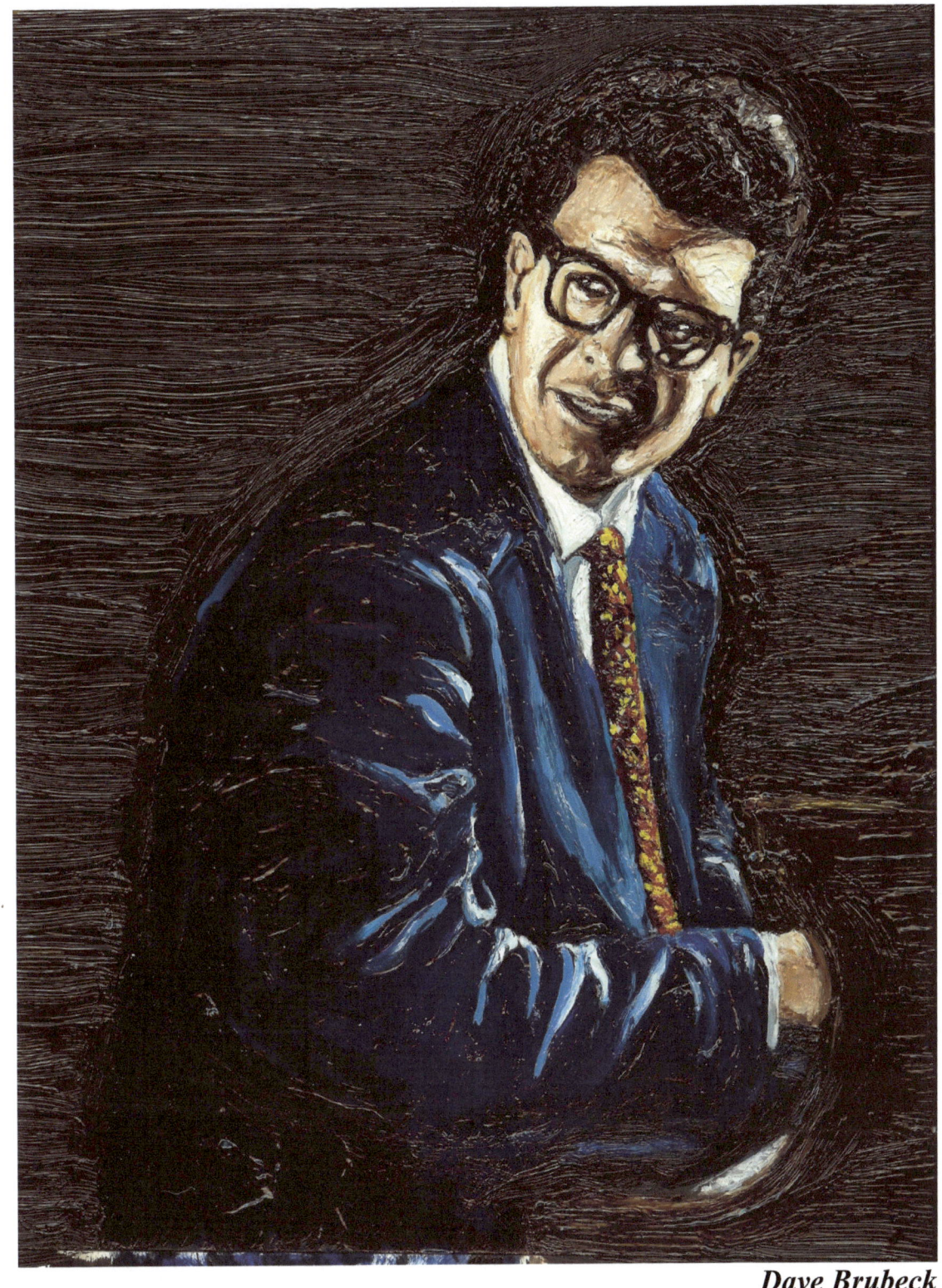

Dave Brubeck

Damn it, when I'm bombastic, I have my reasons. I want to be bombastic—take it or leave it.
> --Dave Brubeck

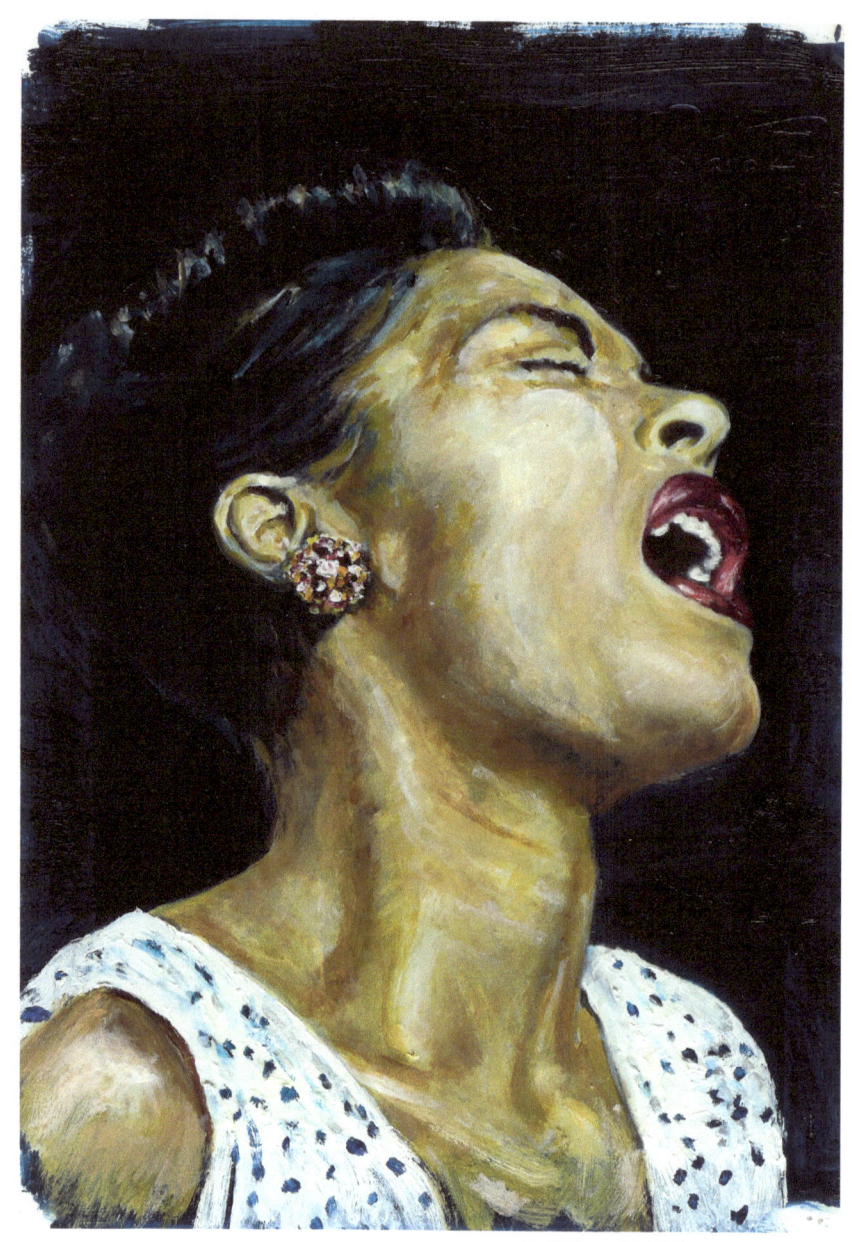

Billie (Billie Holiday)

Billie

No matter what Billie sang the band simply followed
Hypnotized by her voice
In any key
Every song uniquely stamped
Little girl lost in jazz reality
A contradiction—an original
The Lady in Satin
The best jazz singer—ever.

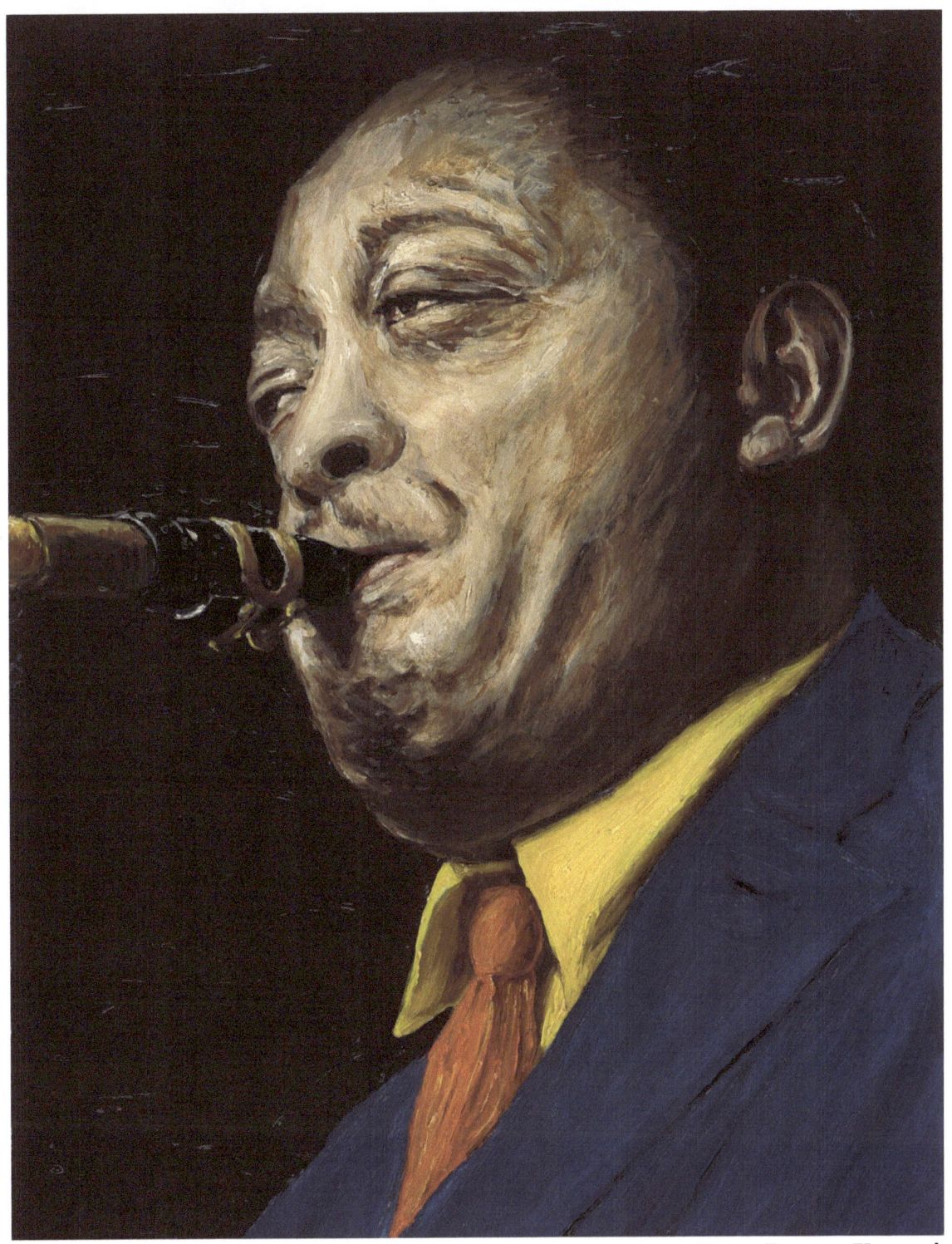

Prez (Lester Young)

Originality's the thing. You can have tone and technique and a lot of other things but without originality you ain't really nowhere. Gotta be original.

--Lester Young

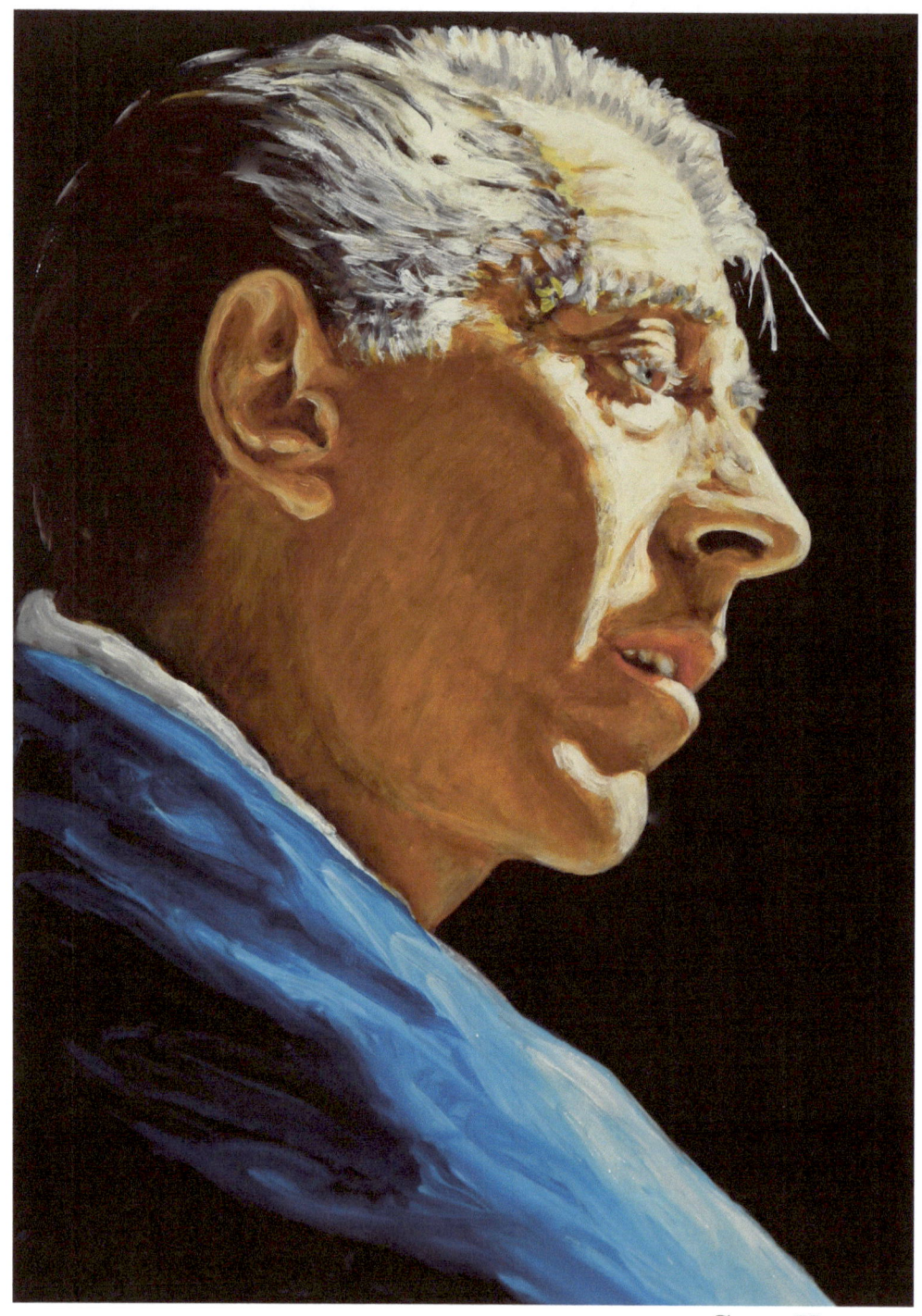

Stan Kenton

Whenever society gets too stifling and the rules too complex, there's some sort of musical explosion.
 --Slash

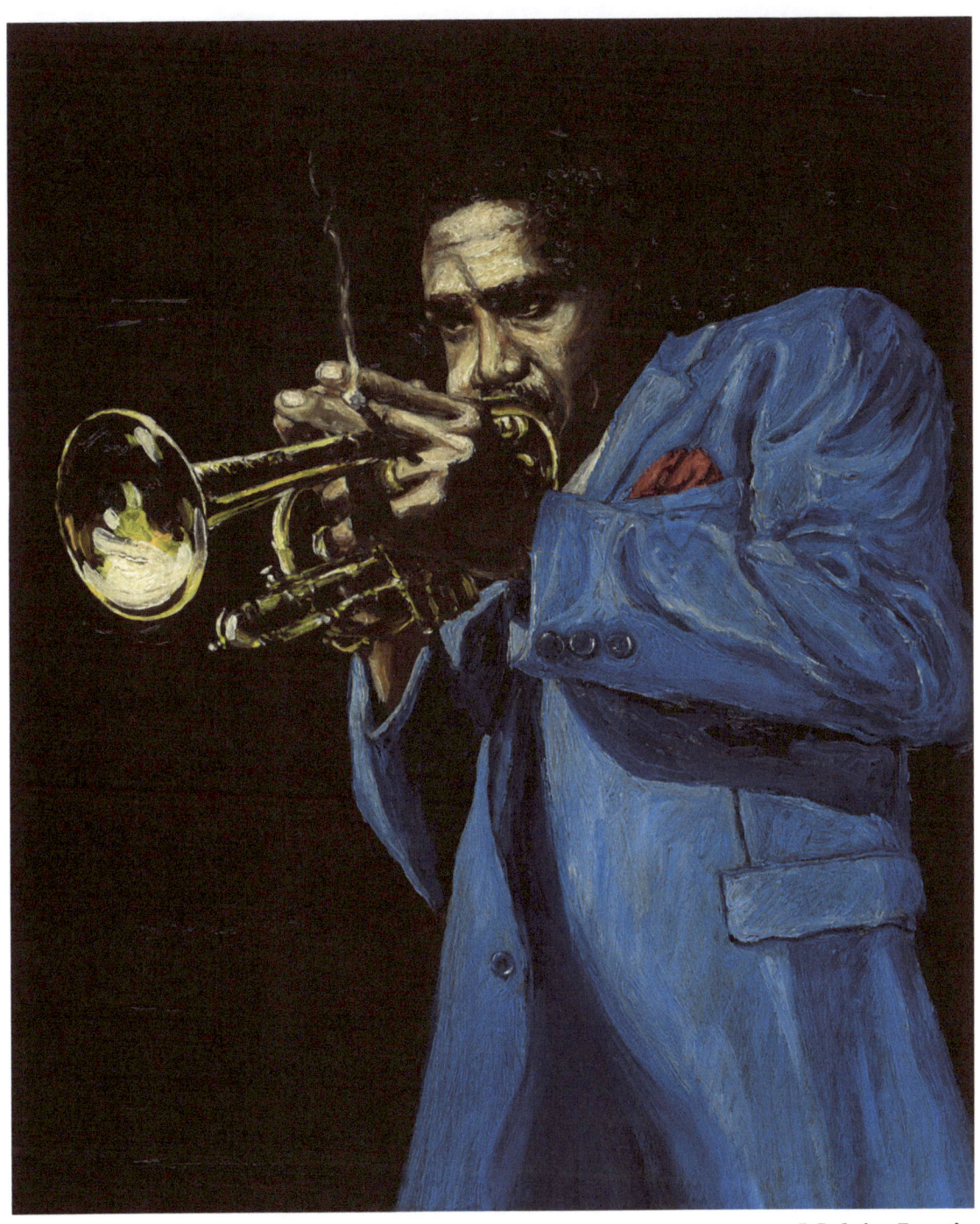

Melvin Lastie

In order to compose, all you need to do is remember a tune that no one else has thought of.
 --Robert Schumann

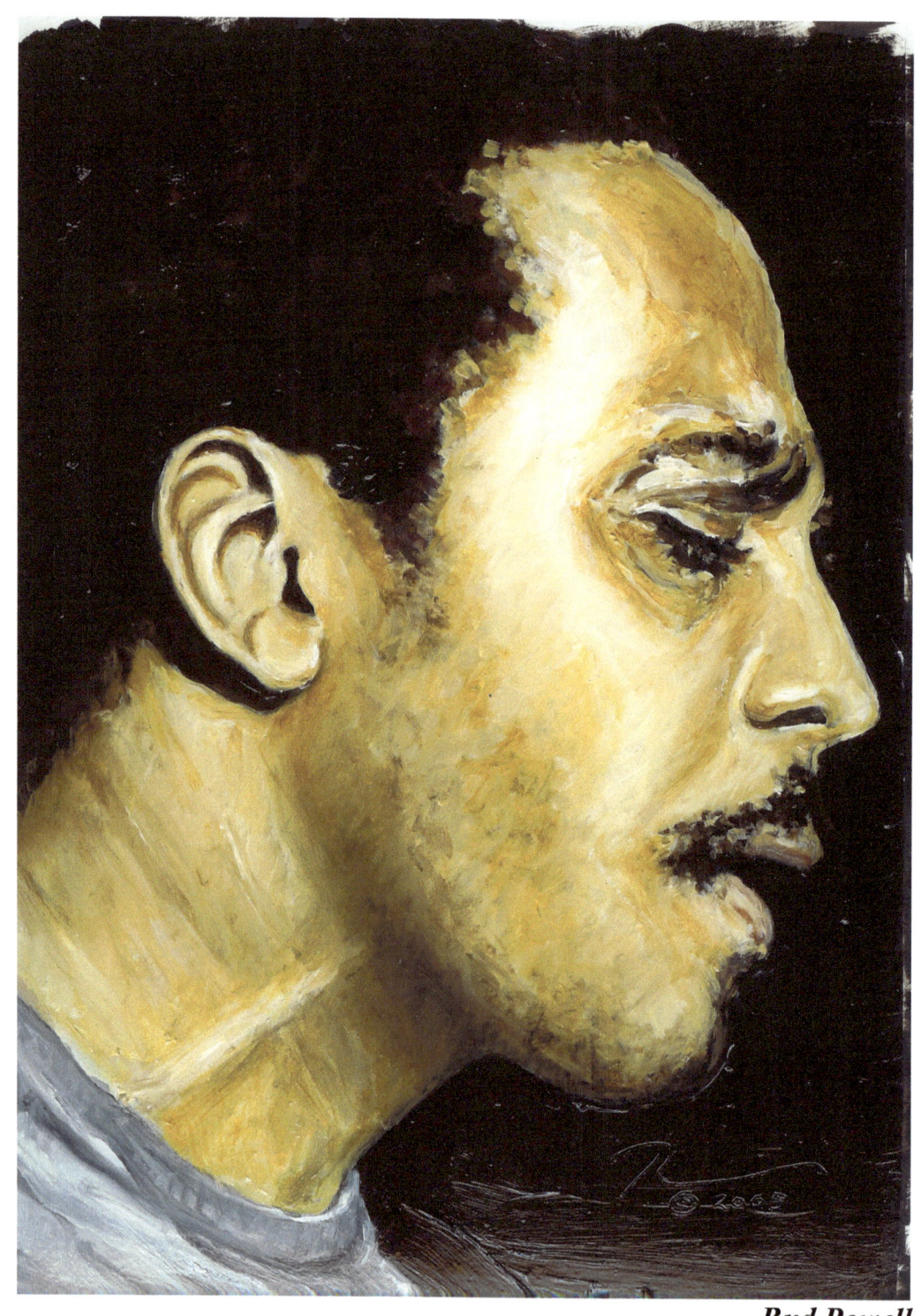

Bud Powell

Only play what you hear. If you don't hear anything, don't play anything.

--Chick Corea

Creativity Has A Price

Creativity has a price

Consuming, affecting, solitary struggles

Misunderstood, dismissed

Ignored, forgotten

The quest persists

The process?

The product?

A choice?

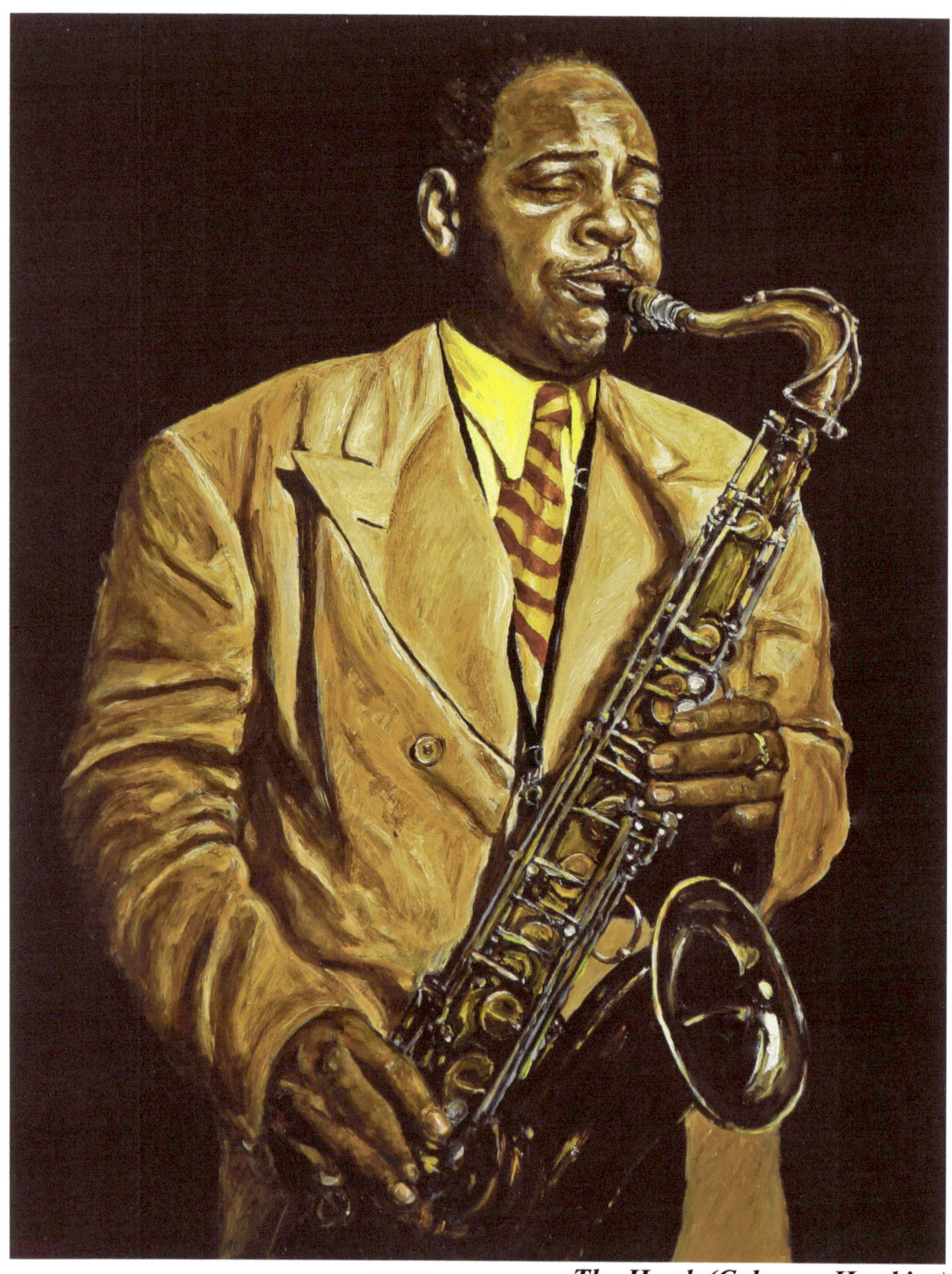

The Hawk (Coleman Hawkins)

If you don't make mistakes, you aren't really trying.
 --Coleman Hawkins

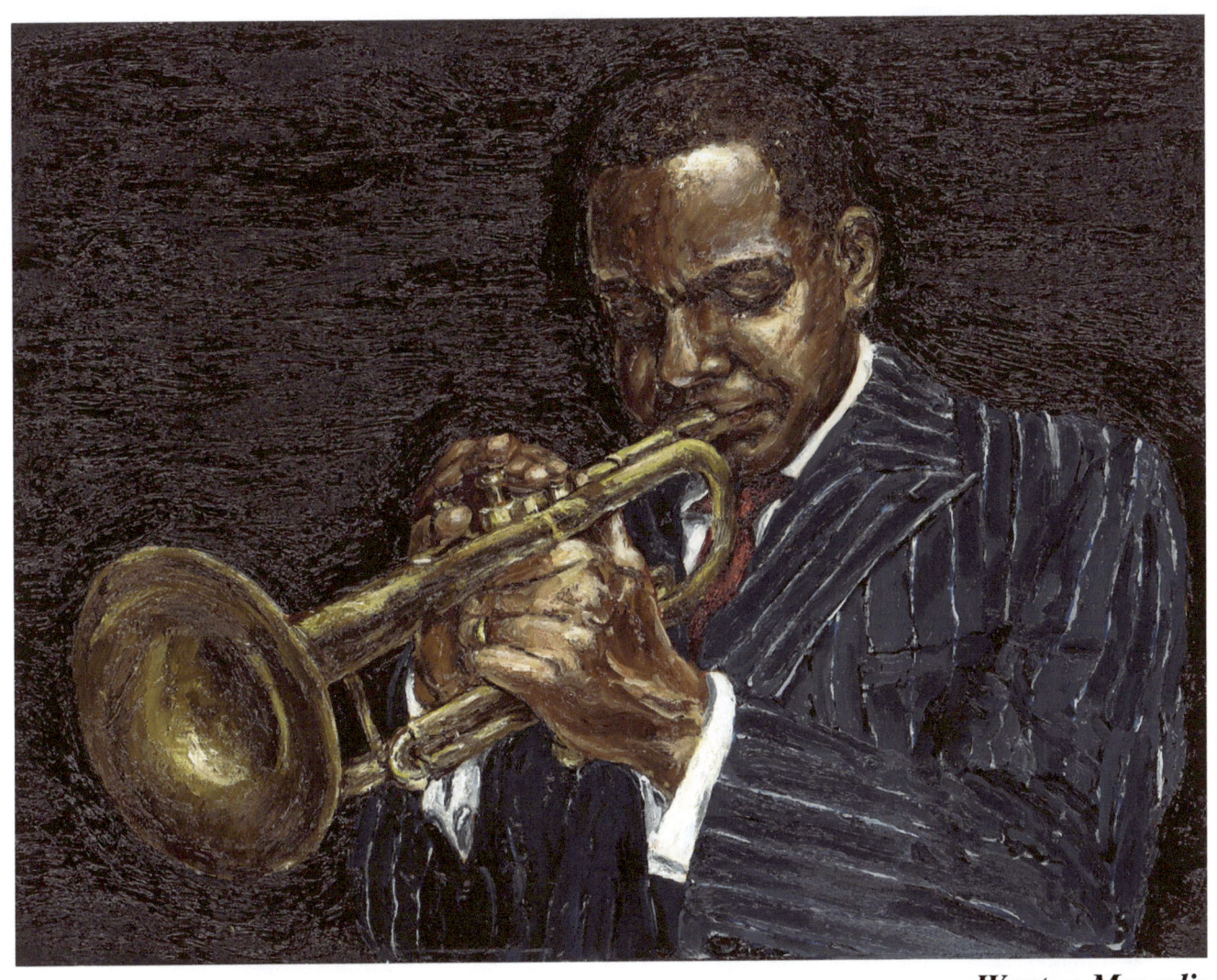

Wynton Marsalis

Well, If I could play like Wynton, I wouldn't play like Wynton.
--Chet Baker

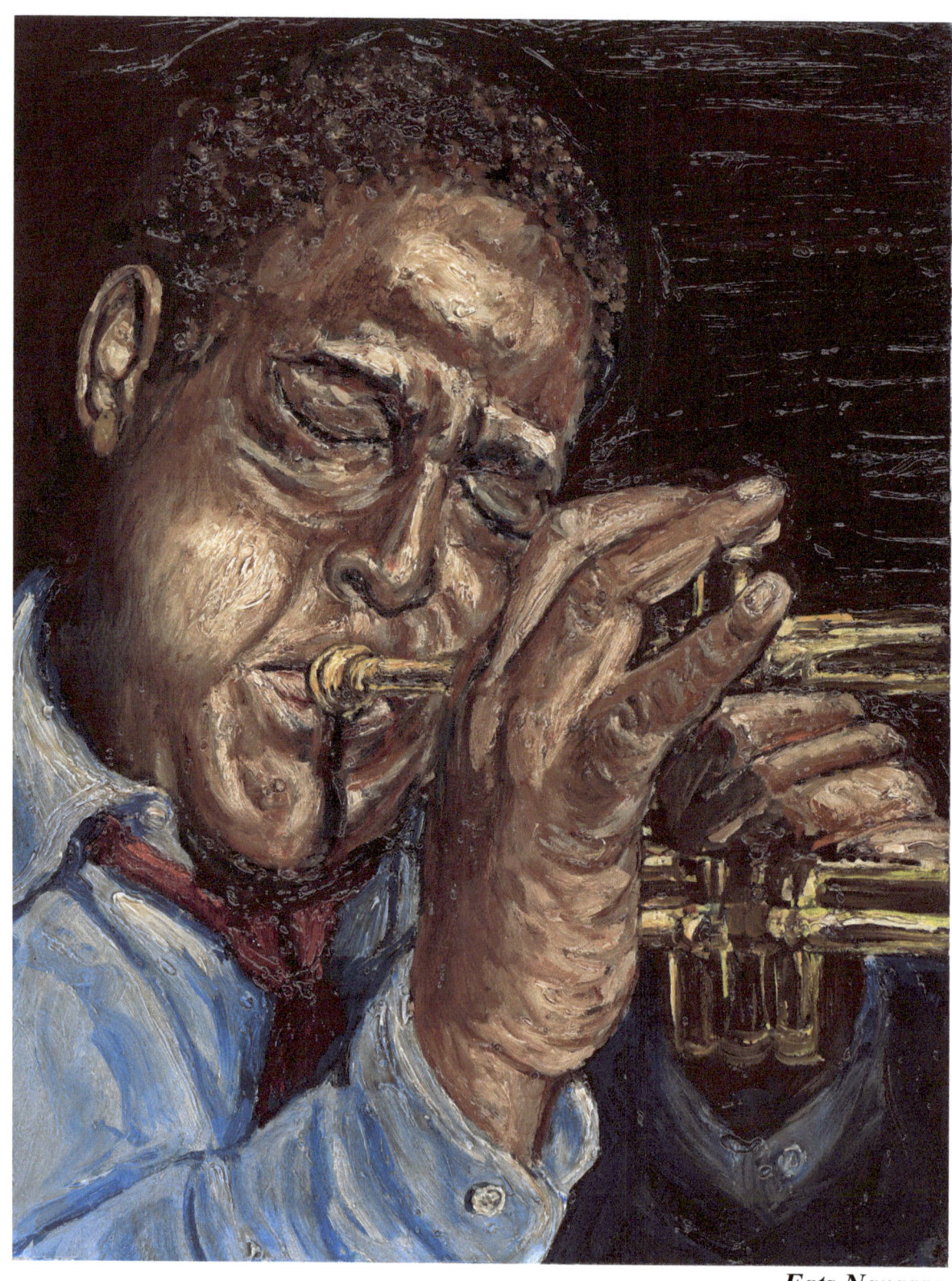

Fats Navarro

Music washes away the dust of everyday life.
 --Art Blakey

Open Minds Discover

Open minds discover
Unseen, unheard treasures
Provoked by inquiry
Arrested by undefined
Incomprehensible newness
Creativity found-
Art lives.

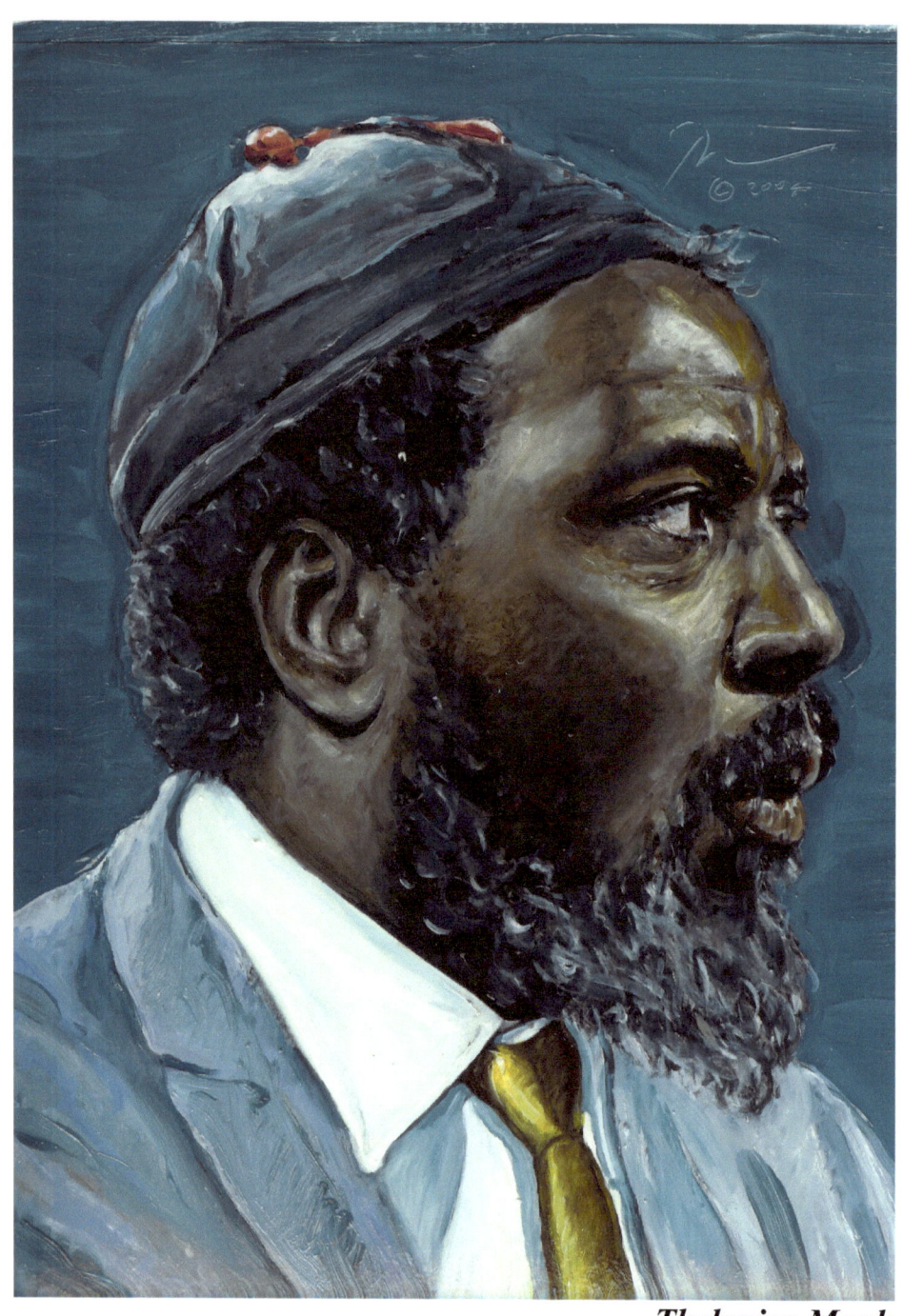

Thelonius Monk

There are not natural barriers. It's all music. It's either hip or it ain't.
--Lee Morgan

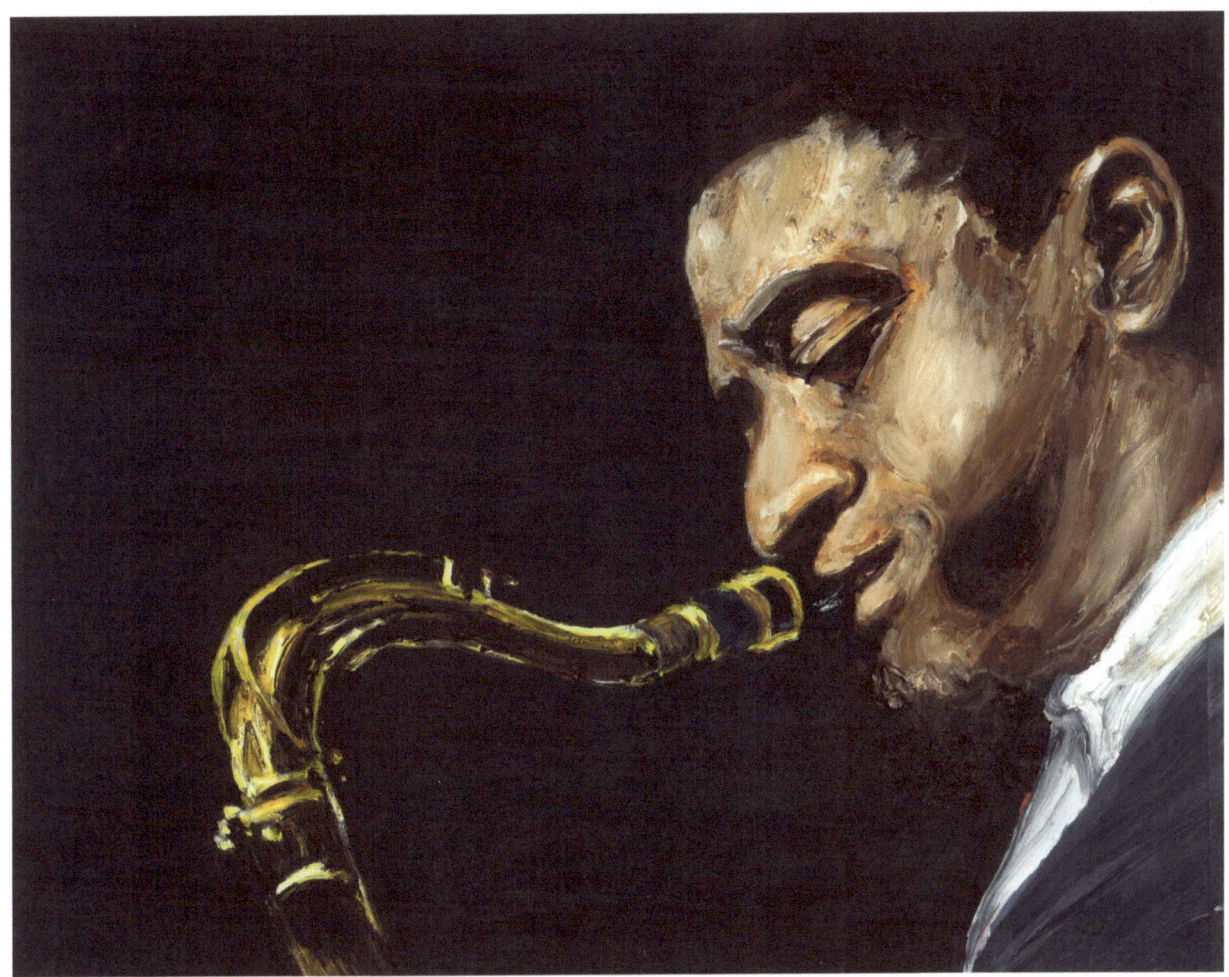

Sonny Rollins

Music is born out of the inner sounds within a soul; all the music that was ever heard came from the inner silence in every musician.
> --John McLaughlin

www.ingramcontent.com/pod-product-compliance
Lightning Source LLC
Chambersburg PA
CBHW040746200526
45159CB00023B/1745